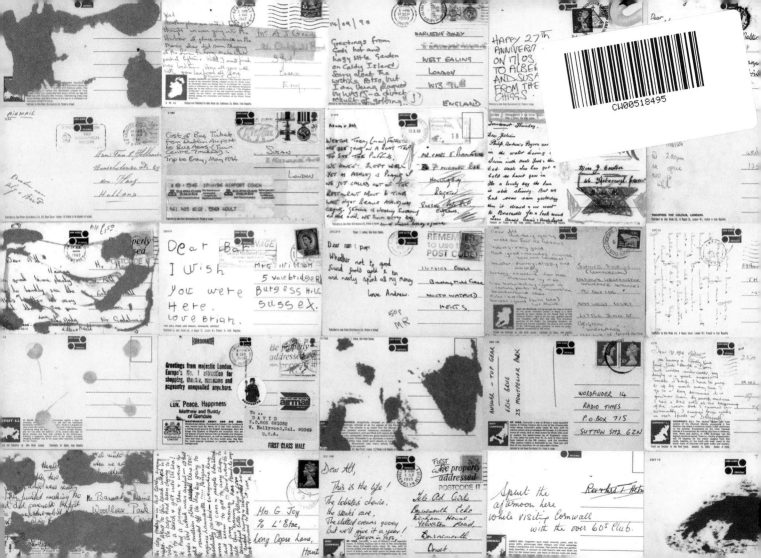

NOTHING TO WRITE HOME ABOUT

NOTHING TO WRITE HOME ABOUT

Celebrating the heyday of the British holiday postcard

A collection of John Hinde postcards and their messages

compiled by Michelle Abadie and Susan Beale

A percentage of the profit from this book will be donated to Carers UK

First published in Great Britain in 2007 by Friday Books
An imprint of The Friday Project Limited
83 Victoria Street, London SW1H 0HW

www.thefridayproject.co.uk
www.fridaybooks.co.uk

ISBN 978-1-905548-36-1

British Library Cataloguing in Publication Data
A catalogue record for this book is available from the British Library

Design by Michelle Abadie and Susan Beale

Printed in China

It is the Publisher's policy to use paper manufactured from sustainable forests

A percentage of the profit of this book will be donated to Carers UK, registered charity number: 246329, www.carersuk.org

Acknowledgements

We would like to thank Ben Highmore, Marcus and Jo Davies, Paul Goodman (Collections Director, The National Media Museum) and Edmund Nägele. Above all, we would like to thank Steven Marshall and all our friends for constantly believing in this project with us.

This book was published with the aim to help raise awareness of Carers UK.

Foreword

Ben Highmore - Reader in Media Studies, University of Sussex

There are two sides to every story and two sides to every postcard. Postcards tell their stories twice: once as image and once as writing. Hinde postcards, during the classic period (roughly 1960s to 1980s), produced an aesthetic that pictured holiday destinations and tourist itineraries as hyper-vivid images. Through glossy production and colour-saturated printing, landmarks, coastlines, monuments, resorts, and so on, were animated by the intensity of a style, a look. For the generations that grew up in the '60s, '70s and '80s Hinde images are part of the fabric of memory. Their very vividness gives them a strange, dream-like quality that provides mnemonic jolts and fleeting glimpses of lost time. Hinde postcards recast the times and places of the past as Technicolor daydreams. Like scenes from *The Wizard of Oz*, where Dublin or Southend-on-Sea has replaced the Emerald City, it is the intensity and quality of the colour that matters.

Yet the pristine image, reproduced by the thousand, always becomes singular: bought, written-on, stamped, addressed, sent, received, read, discarded, collected, forgotten, or remembered, the postcard is always inscribed by the peculiarity of time, by the particularity of a writer. Postcards in the singular tell stories about the insistence of everyday life: holiday-time filtered through mundane reminders of daily habits. These written-on and sent postcards constitute a minor archive of an anecdotal social history punctuated by minor ailments, missed opportunities, and the pleasure of places seen. If the images offer an idealised vision of a leisurely postwar Britain and Ireland, the writing tells another story. The writing carries these images home; it brings them back down to earth.

Michelle Abadie and Susan Beale have put together a collection of used Hinde postcards where the most immediate pleasures lie in the nostalgic recognition of the image, and in the humour to be found in the holidaymakers' unguarded messages. But amid these generous pleasures lies buried a secret history. Look carefully and read attentively and you will be alerted to two noble truths. Firstly: eccentricity and idiosyncrasy are not the exception, but the rule. Secondly: the business of British holidaymaking has generated a deep everyday surrealism (it is not for nothing that 1936 saw both the first International Surrealist exhibition in London and the opening of Billy Butlin's first holiday camp at Skegness). Here then is a vision of a nation at leisure, characterised by the shared strangeness of holiday destinations, by a democracy of peculiarities.

John Hinde F.R.P.S

The National Media Museum

John Wilfrid Hinde was born on May 17, 1916, in Street, Somerset, the great-grandson of James Clark, the founder of C J Clark Ltd., the shoemakers, of which his father was a director. In 1919, an illness left Hinde with a permanent disability in his left leg that subsequently involved him spending much of the next eight years on his back. In 1930, the local village chemist encouraged Hinde's interest in photography and in 1934, during his last year in school, he attempted to make his first colour photograph. He then joined the family business only to leave it to study architecture in a Bristol-based practise in 1935.

Hinde continued to work in black and white, making his name in the RIBA annual photographic competitions, and experiment with colour photography (using the notoriously difficult three colour carbro process) between 1934 and 1937; during the latter year he was elected as an Associate of the Royal Photographic Society and became a Fellow in 1943. The year of 1937 was important in other ways, too, in terms of how Hinde's methods and aesthetics of colour photography evolved. Enrolling at the Reimann School to study photography, he was taught by Frank Newens, a leading exponent of new methods of colour printing. Hinde then set up a studio in London in partnership with John Yerbury in 1939. During the 1939-45 War he acted as a war photographer covering scenes of the Blitz and for the rest of the 1940s was pre-occupied with the reproduction of colour photographs in books. Of particular interest is his work with Adprint publishers who developed the 'Britain in Pictures' series, an association that links his work with war-time Britain and the propaganda potential - as well as the creative possibilities - of colour photography. Hinde also exhibited

his colour prints in RPS exhibitions as well as lecturing to the Society while pursuing other publishing projects with Collins and Harrap.

In 1944, he was included in Cecil Beaton's important book, *British Photographers* in recognition of the artistic success he had attained with the colour process. Throughout this period, Hinde was prolific as an artist, advertising photographer and, to some extent, entrepreneur. He travelled to America in the hope of getting involved with film, travelled around Ireland showing cinema films in village halls and toured Britain with Reco's Circus. In 1949 he became PR manager for Chipperfield and Bertram Mills circuses where he met his wife, Jutta, a flying trapeze artist many years his junior. After a failed attempt to open his own travelling variety show in 1955, he returned to photography and founded John Hinde Limited, the company through which his colour work would reach an international audience. A notable series in this new project was the set of photographs made for Butlin's of various holiday camps, but other postcard subjects included beach scenes, indigenous activities and tourist related themes from America, Africa, Asia, and the West Indies. The most extensive postcard work was carried out, however, in Britain and the Republic of Ireland. Elmar Ludwig and Edmund Nägele were the first photographers John Hinde employed.

Hinde's success in the postcard business parallels the post-war expansion of the tourist industry. Within a decade, the portfolio of Irish postcards, for example, increases from 30 to 300. From his base in Dublin, the Hinde company expanded rapidly until its sale in 1972 at a time when sales were in excess of 50 million postcards (or viewcards as he preferred to call them) worldwide. Following his retirement from the business he moved to Continental Europe, where he lived in France and Spain until his death in 1997.

Despite the evolution of Hinde's fascination with colour from the exhibition print, to book illustration, to a mass-produced format, he is widely regarded as a formative figure in the dialogue between the fine arts, design and popular culture. Recently, a book and exhibition have celebrated this overlooked figure in the art of photography, a celebration that acknowledges the popular resonance of his postcards and his publishing achievements, but also the sublime, optimistic and dream-like appearance of his colour photography that is a vital resource for understanding the social and cultural history of twentieth century Britain.

Finally, the currency of Hinde's work has shifted. In 2003 and 2004, an exhibition dedicated to the Hinde Company's work toured internationally and to great acclaim. This is testimony to the place his work now occupies in contemporary consciousness within the visual arts. His pictures reflect a fascination with the everyday, subject matter that was close to the imagery in the 1950s and '60s that characterised Pop Arts' engagement with popular culture. That culture needs to be preserved and better understood as a distinct cultural form as well as being acknowledged as a source for creativity.

Hinde's contribution is layered and without precedent; the John Hinde Archive offers a way of articulating the intricacies of the colour process through an oeuvre that so richly illustrates the technical and aesthetic possibilities of the medium.

The National Media Museum acquired the John Hinde Archive in 2007.

(www.nationalmediamuseum.org.uk)

Wish you were there

Edmund Nägele F.R.P.S. - photographer

In the early days of 1968 the John Hinde team, all two of us (Elmar Ludwig and myself) were presented with a list of about 80 subjects to photograph during the yearly season of five months. The knowledge of the expensive retouching wizards at a far-off place in the sun who produced the 4-colour separations never crossed our minds; we were required to get the best shot possible, no matter how long it might take. And take, it would, quite often several weeks for a single postcard scene. We shot on average only one or two sheets of 5x4 Ektachrome transparencies per subject. It was in fact easier than today's approach of running off 160 frames on the digital flashcard. In retrospect, it saved hours of faffing around finding the best scene amongst all the thumbnails, TIFF's and JPEG's - if indeed, there can be such a best scene, with such a happy-go-lucky approach. The exposed sheets of film were carefully kept in a Kodak film-box until the return to Ireland many months later. Here we processed the material ourselves at the little old "Studio" near Bulloch Harbour. That little old studio was Mr Hinde Senior's original home and the location was simply magical yet very damp on the days the Irish merely call "soft". At lunchtime one could pop out to buy a single Woodbine cigarette at the small store at the harbour quay. I gave up the habit a long time ago, but still remember those little treats with some affection.

Take the photograph of Longleat House with the Lions of Longleat posing so prominently in the foreground. John Hinde Limited got the contract to produce a series of postcards for the park and house and I duly arrived with Land Rover & caravan which I parked within a field full of mucky-bottomed sheep but thankfully minus the lions, yet still within sight of the

magnificent house. In the late afternoon and evenings I would undertake the interior shots whilst during the day I ran away from giraffes, got nibbled by some little chimps and tried to get on a good footing with the main attraction: The Lions. The above-mentioned shot was long in the planning and the Longleat safari Land Rover was well equipped with fresh meat from the butcher. Off we went, throwing large lumps of fillet steak around the scenery and eventually coaxed the big cats into the position

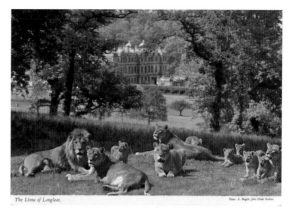

The Lions of Longleat.
Photo : E. Nägele, John Hinde Studios.

where the house could be seen in the background. Lions are a lot worse than kids and are born with the illusion of sitting on an anthill. Finally, they settled in a group. I used a Bronica for the shoot and the first wallop of the mirror and clattering of the shutter sent them bounding off in various directions without giving me so much as another look. The ants again! I had one shot and 11 empty frames on the roll of film. Not a good feeling, but there it is, printed in four colours and on glossy paper.

John Hinde was not a man of many words, but he had a good and precise idea of what he wanted the finished product to look like. He would sit at the light-table, looking at and scrutinising one's work in silence, umming and arring, but I soon found out that this umming and arring was like the purring of a happy cat. If the purring stopped, he might ask, "Why didn't you wait for this crummy car to move?" or "Ed, why didn't you wait for the clouds to

move a bit more towards the edge of the picture?" It took him probably ten minutes to look and mask-up each and every transparency.

After John had masked the transparencies, black and white negatives would be produced and the enlargements for the colour-notes would be made. John would start preparing the instructions for the colour separations, which were produced in Italy. No PhotoShop here, but skilled Milanese Signores who would change colours, follow the scribble 'make new sky' or insert the perfect holiday wish and remove objects of lesser desire. Telephone posts and TV-aerials scored high in this department. More desirable items included people and cars thus the scribbles went into overdrive: 'make jumper red' and 'change colour of car to yellow'. Why red or yellow? Simple, it made the finished cards stand out on the souvenir stands. It would take some six to seven months before the first colour proofs reached Ireland. It was a very slow and expensive process, but also exciting to see one's photographs in their first form of print.

People always played an important part in John Hinde postcards; they gave the picture life, a point of interest and most importantly, a blob of colour. People were happy to while away their time posing for some crazy guy with a foreign accent and gladly pointed towards a far distance of nothing. Money was a dirty word, though we sometimes offered it in exchange for flowers from a cottage garden to place in foregrounds of shots. Never once was it accepted. Quite the contrary, kind people would offer tea and biscuits and the time to chat with you. How things have changed. Whatever has happened in the past 35 years to take away this kindness? Wish you were there? Bet you do!

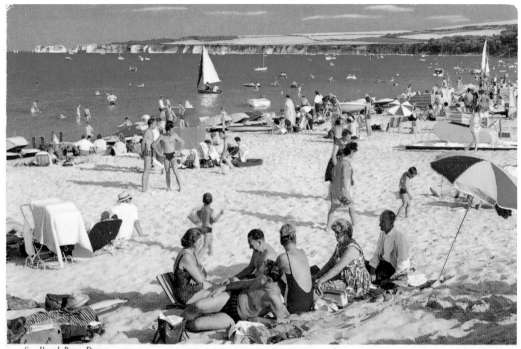

Studland Bay, Dorset.

Photo: E. Ludwig, John Hinde Studios.

22 Aug 1980, sent to Hull, Humberside
What would Winston make of all this, I wonder. Uncle Harold

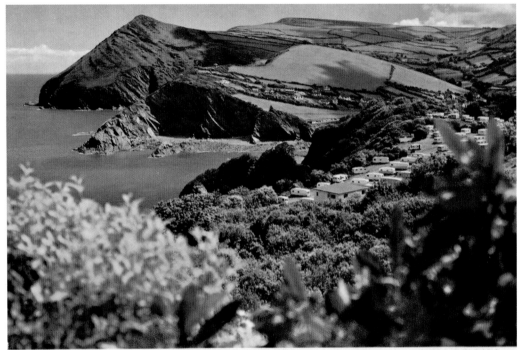

Hangman Hill, Combe Martin, North Devon.

Photo : E. Nagele, John Hinde Studios.

23 July 1975, sent to Reading, Berkshire
Dear A Bee, we left home at 5am Saturday and took 11 hours to get here. We travelled 3 miles in 3 hours on the M5 at Taunton and then a long slow crawl all the way to Lynmouth. Needless to say we were delighted to have a certain gentleman's company for a while. Caravan site is midgey. Till we see you out, good wishes, Nora & Alan

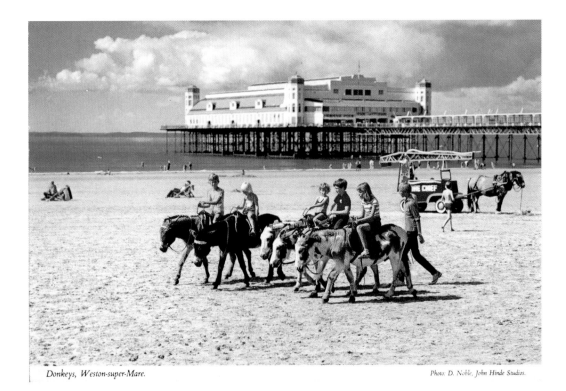

Donkeys, Weston-super-Mare.

Photo: D. Noble, John Hinde Studios.

10 Jan 1990, sent to Oxted, Surrey
Dear Dad, the bus flew home from W-s-M in record time instead of 1 hour it took 1/2 hour. Been picking up teddy bear money for the blind. Played darts last night and been watching it on the tele very good. That Mrs Rigby is a bloody nuisance really keep phoning you up. We start the second half of the skittle season tonight see if we can get off the bottom of the table. I dont think Mike will employ Malt after Monday that was the last straw, Bye Eric

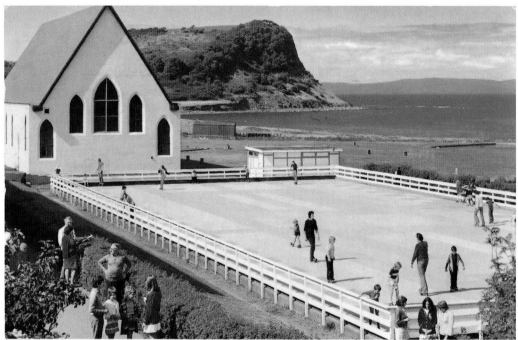

BUTLIN'S AYR—*The Skating Rink & Heads of Ayr.*

Photo: D. Noble, John Hinde Studios.

11 June 1974, sent to Leslie, Fife
I have Been on the Skating Rink narly every day. having a nice time. Chris Bryers

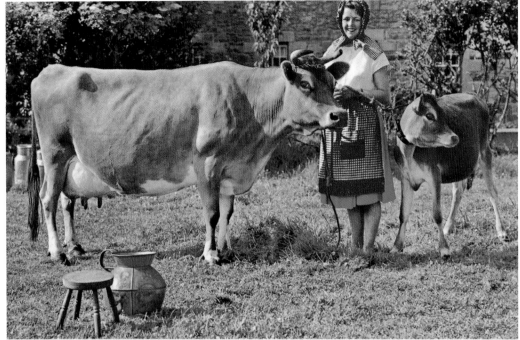

A Milkmaid with Jersey Cow and Calf

Photo: E. Ludwig, John Hinde Studios.

10 Aug 1966, sent to Wareham, Dorset
Dear Auntie Hilda & Uncle Derek, hotel is on the beach, very comfortable but sand everywhere. We are yards from the sea but cant see the water through the windows. Dave is bringing back a very large grey and white budgie with webbed feet. From Phyllis and Cissy (Sorry this is a close-up picture)

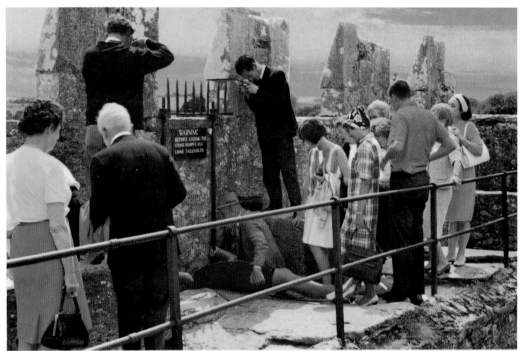

Kissing the Blarney Stone, Blarney Castle, Co. Cork, Ireland.

Photo: Joan Willis, John Hinde Studios.

5 May 1969, sent to Bexhill-on-Sea, Sussex
I was very pleased to get your long letter. I hope you will not have more 'attacks' its horrid when you have to live alone, so glad you have a nice and good neighbour. I had four more injections yesterday into my feet. No it's not the arthritic cure that's talked about but all the doctors say it's definitely on the way and will be available in about two years that will be too late for me I'm afraid. Hester Shoe

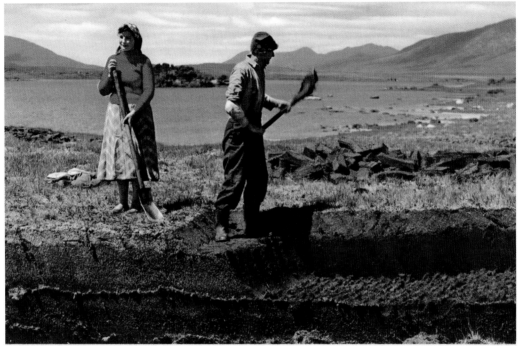

Cutting Turf near Oughterard, Connemara, Co. Galway, Ireland.

Colour Photo by John Hinde, F.R.P.S.

1967, sent to Norfolk

Thursday afternoon we received our tickets at Norwich only to find they had booked us to start from London - and they had to phone ahead of us asking for us to be passed through at Manchester - we left Manchester yesterday morning - arrived at Dublin - only to find the air company had lost our luggage - all we have is our pyjamas, a change of shoes and Fred's shaver! They put through a trunk call - but it was not left at Manchester - they think it was put on the wrong plane and shall be going places - we spent last night at Enids - and came onto Galway this morning - we go to Limerick tomorrow - keep phoning the airport - they are trying to trace it but no news yet. We were delayed 6 hours yesterday - our plane got trouble - and twice they loaded us aboard and then we had to get out again and finally came on another plane - its been sunny love Fanny

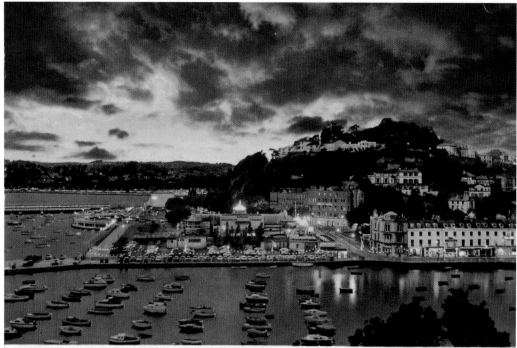

Twilight over Torquay Harbour, South Devon.

Photo : E. Nägele, John Hinde Studios.

28 March 1966, sent to Bournemouth, Hampshire
Dear Mum & Nan, it really does look like this at night (for daytime see Mr & Mrs P) This almost the view from our window - we can see a lot more to the left. Sylvia is a lot better. Had a doctor to Bert Monday morning, he is very queer. Not certain what it is. Hope to be home Sunday. Love Cherry & Bill

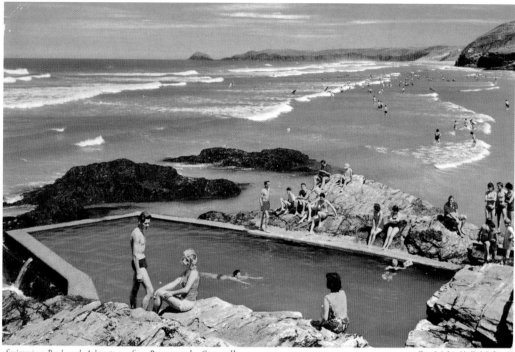

Swimming Pool and Atlantic surf at Perranporth, Cornwall.

Photo: E. Ludwig, John Hinde Studios.

23 May 1967, sent to Porthcawl, Glamorgan
Dear E, Just a P.C. of a place you may remember. Had 2 letters from your solicitors, will let you know my requirements. Hope you are O.K. Walter

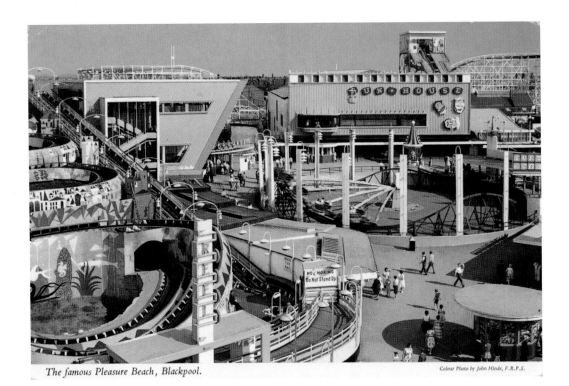

The famous Pleasure Beach, Blackpool.

Colour Photo by John Hinde, F.R.P.S.

1974, sent to Melton Mowbray, Leicestershire
Having a nice time
Kind Regards to All
will be running whist @ W.M.C. Starting in 2 weeks.
Bill W.

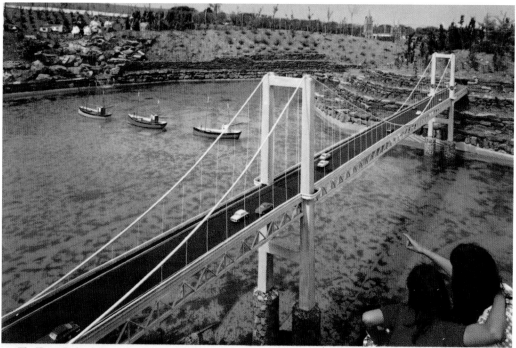

The Tamar Bridge, "Cornwall in Miniature", St. Agnes.

Photo: E. Nägele, F.R.P.S.

Date unknown, sent to Worcester
Hello Bert. Rang to tell you I had poped off but you were away, Yvonne

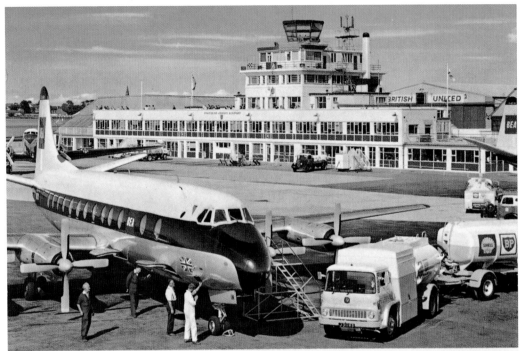

The Airport, Jersey, C.I.

Photo: E. Ludwig, John Hinde Studios.

1984, sent to Wimborne, Dorset
Hi John! Great and surprised very pleasantly to meet you on the gentlemans frequencies. All ways a pleasure to catch you by no matter where. Very good this way. Did manage Brazil and Perth on SSB at 1700 hrs. Hope to copy you soon again in the near future. Good Dxing. Regards Joe 21 at 659 (Silver Fish)

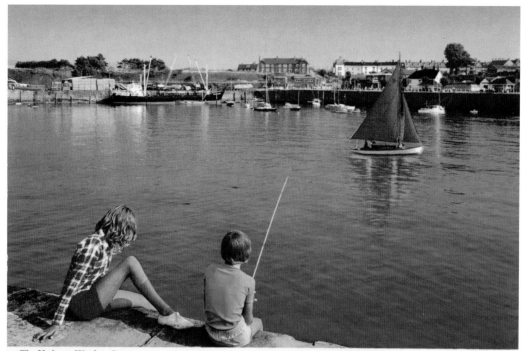

The Harbour, Watchet, Somerset.

Photo: E. Nägele, F.R.P.S.

Date unknown, sent to Oxted, Surrey
Been working in Exeter putting out soft toys. See Weston and Clevedon got the blue flag of European beaches they must be blind. See all the bills for gas have gone up. Played darts last night we lost 5-4, saw that programme on squirrels very good. Watched Ronnie Barker and Frankie Howard very funny. Exeter not easy to drive round full of traffic lights these days. See the speedway even gone up by 50p at Swindon, Best Regards Eric

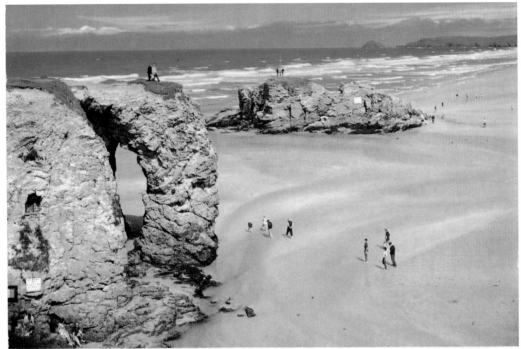

The Beach and Chapel Rock, Perranporth, Cornwall.

Colour Photo by John Hinde, F.R.P.S.

13 April 1982, sent to Sealink staff, Southampton, Hampshire
Saturday, time is passing now, not dragging as usual. We have quite a hectic programme each day, but have had some interesting conversations with people. A good number attended a Christian Musical entitled 'The resurrection' held last evening. This evening we have a film called 'A Thief in the Night' which we have been inviting people to see. Stella was stung by a wasp and brandy has helped us all. Bye for now. P.S.I bet its quiet without Wes! Ken

Cornhill Market, Bridgwater, Somerset.

Photo: E. Nägele, F.R.P.S.

10 Aug 1989, sent to Oxted, Surrey
How are you, have been dropping leaflets. Balloon Fiesta this weekend should be good and the Red Arrows fly over. Saw a programme on Red Arrows on BBC 2 very good. There will be a few pictures so you can have a laugh about the wedding. No skittles down the aisle just a glass of wine. They showed me how to throw money down the drain at Weston. Thanks for treating us to dinner in the Wimpey. Best Regards Eric

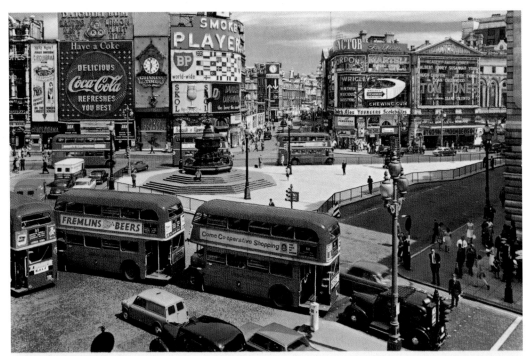

Piccadilly Circus, London.

Photo: Franz Lazi, G.D.L.

5 Aug 1975, sent to Croydon, Surrey
Dear Auntie & Weenie, I arrived at this bright new city at 7.10pm. I was home by 7.25pm. I was lucky in only having to wait 8 mins at Victoria for my train to leave and 2 mins for a 54 bus. It is hot here so I hope I haven't brought the fine weather back with me. I am going to see Pat, a 17 yr old a few doors from us, who has just returned from a fortnight holiday in Yugoslavia, which she spent in hospital. Her mother has just told me that although home she is in bed. Love to all from both of us, Eva & Maurice

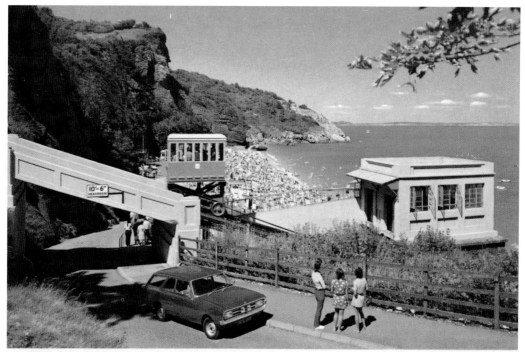

Cliff Railway and Oddicombe Beach, Babbacombe, Devon.

Photo : E. Nägele, John Hinde Studios.

15 Aug 1979, sent to Cambridge
Met Michelle's headmaster on the beach within one hour of arrival. Thanks for the clotted cream. Have spent our time on the beach and picking mushrooms at Paul's. Love Michael and Anita

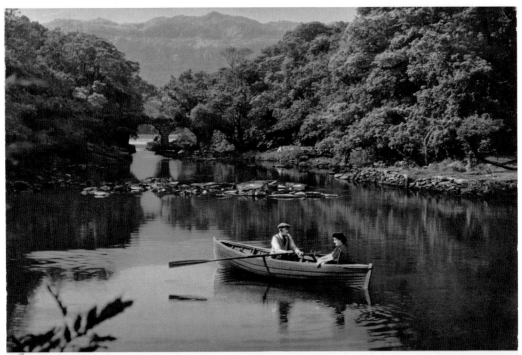

Meeting of The Waters, and Old Weir Bridge, Killarney, Ireland.

Colour Photo by John Hinde, F.R.P.S.

31 July 1985, sent to Bury, Lancashire
This is a beautiful place Killarney Lake and park is a gift to the nation not to be commercialised and it is gorgeous. Were in bantry bay today and it is v v hot. AH

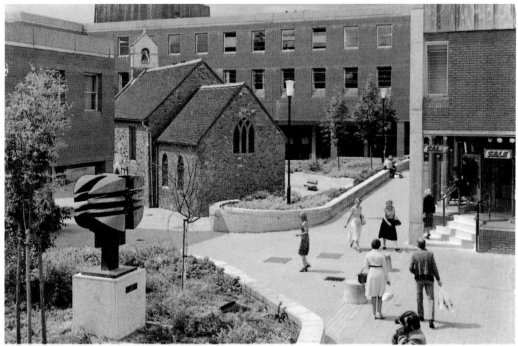

The Guildhall Shopping Precinct, Exeter

Photo: D. Noble, John Hinde Studios.

Date unknown, sent to Sidmouth, Devon
I didn't manage to write to Phyl - because I didn't know what she is called. So I guess we play it by ear.
See you by the VISITORS' entrance 3.30 Wednesday. Love Mary

St. Mary Magdalen Church, Taunton, Somerset.

Photo: E. Nägele, F.R.P.S.

12 Sept 1974, sent to Wiveliscombe, Somerset
Dear Mr Greedy, just a note to say that I shall be in London in time to discuss a letter I had from a Mr
Capon from Budapest. See you soon. Ben

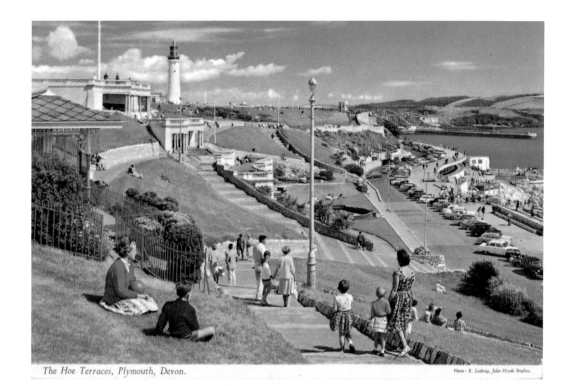

The Hoe Terraces, Plymouth, Devon.

Photo: E. Ludwig, John Hinde Studios.

Date unknown, sent to Tiptree, Essex
Candy isn't very well, have to take her to a vet tonight. I think she has screws in her back legs, she can't walk very low. Hope you are enjoying good weather also. Do you remember walking up here in 1947 and when we swam at midnight, the moon like a paper lantern? Remember us to Alec and Jack. Love for now, Lis and Bill

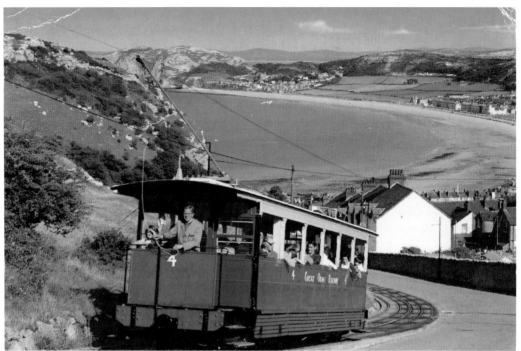

Great Orme Railway, Llandudno.

Photo: E. Nägele, F.R.P.S.

4 Sept 1978, sent to Freshwater, Isle of Wight
Hope you are having an enjoyable holiday with good weather. Here is dry, but overcast. Stan Neem says
to be remembered to Claude - if he remembers him! If not, withdraw it! Love from Bernard

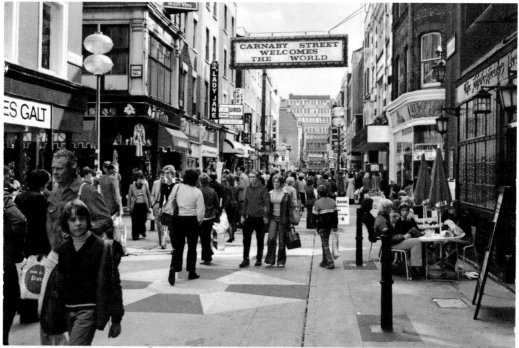

Carnaby Street, London.

Photo: D. Noble, John Hinde Studios.

25 July 1975, sent to Solihull, West Midlands
Fri, hello, I'm having a great time got a pair of jeans and a silver ring yesterday. Went to the PO tower it was closed, was going to Battersea fun fair, pulled down last year (Clares fault). We are just going boating on the serpentine, and we went ice-skating yesterday and we were great. Give dad and mum a big kiss for me please, don't know if Geoff and Paul will want one. Love Katie

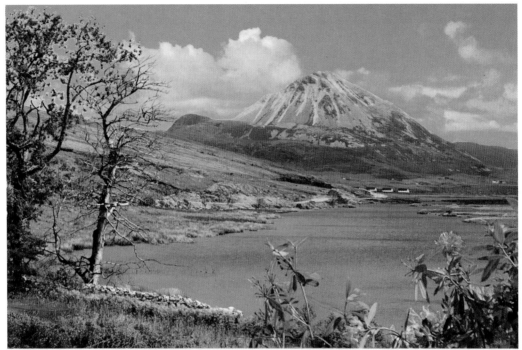

Errigal Mountain from Gweedore, Co. Donegal, Ireland.

Colour Photo by John Hinde, F.R.P.S.

1969, sent to Mid Glamorgan, Wales
Thelma & Des, everything fine after the storm, apart from me down with the gout. So don't laugh.
Regards to all, Fred

Chagford, Dartmoor, Devon.

Photo: D. Noble, John Hinde Studios.

June 1984, sent to Worcester
Dear Ethel, it was a lovely day here. We stopped on the way to pick up May who is about my age and very nice. How we have laughed about all the things that have happened in my life. Peter says I don't get any better. Of course he doesn't like my mother or my sister so has been very intense. Lots of love Mavis.

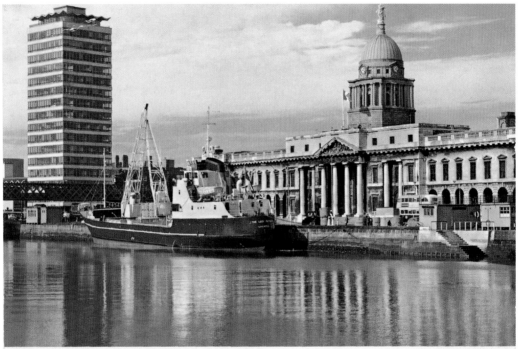

Liberty Hall, Customs House and River Liffey, Dublin, Ireland.

Photo : E. Nägele, John Hinde Studios.

4 April 1967, sent to Ilford, Essex
We had the misfortune to be in the same hotel as some of the Welshman over for the rugby match. They were a rowdy lot and we had to complain to the manager when one of them locked himself in the toilet one evening and wouldn't come out. We've a funny sequel which we'll keep for later. Brian says he didn't have any experiences like that last time he was here. Thinks its all my fault and if I don't like his beard he's going to shave it off. Love Marg & Brian

The Peastacks & Jerbourg Point, from Moulin Huet, Guernsey, C.I.

Photo: H.Gössler, John Hinde Studios.

9 Aug 1970, sent to Worthing, Sussex

Dear Mr, Mrs Horden; am having a lovely time. Have just bought a pen that writes underwater, my dinghy is a great success. Trouble is though I have to pump it up by mouth every time I go to a bay because it is quicker than by pump machine. I had a bad cold at the beginning of the week but I carried on normally. I coughed large crabs in rock pools. Ditty Mark

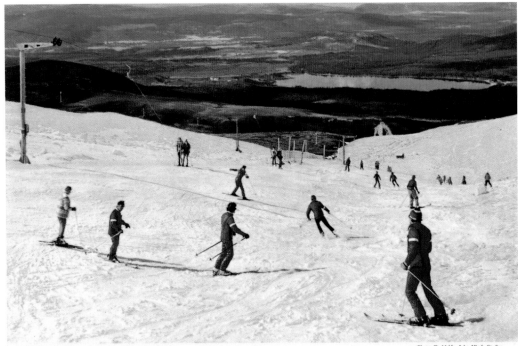

Skiing at Aviemore, Inverness-shire, Scotland.

Photo: D. Noble, John Hinde Studios.

Date unknown, sent to Bolton-by-Bowland, Yorkshire
Snowing like mad, skiing not bad altho' I think I'm taking it too seriously - must laugh when all over.
Nothing to write home about. Love Kate & Keith

Corfe Castle, Dorset.

Photo: E. Nägele, John Hinde Studios.

Date unknown, sent to Westcliff-on-Sea, Essex
Dear Lucy & Trevor, It rained on Sunday so we went for a drive to nowhere in particular. We don't have cockerels but at 2 0'clock every morning the disco next to our caravan ends and makes a lot of noise although I never wake up. Come and see us soon before you have the kids, please. Bob & Sue

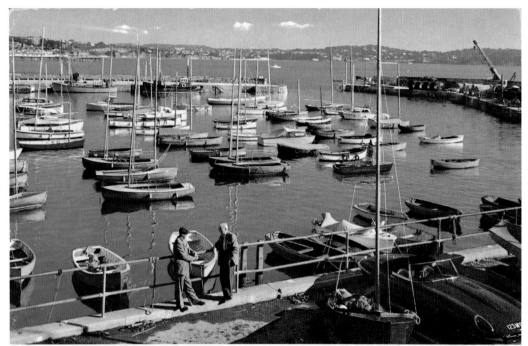

The Harbour, Paignton, Devon.

Photo: E. Ludwig, John Hinde Studios.

June 1987, sent to Crediton, Devon
John and Sarah have a son born this morning June 15th 8lbs, 10 oz Stephen John, both mother and baby
doing well, John rang this morning. Love mummy

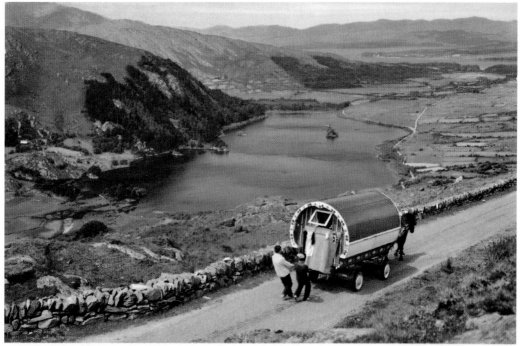

Glanmore Lake, and Kenmare Bay, Caha Mountains, Co. Kerry, Ireland. Photo: Joan Willis, John Hinde Studios.

12 July 1980, sent to Exeter, Devon
Hi there, Having a fantastic time, my Uncle is a great laugh. The food is great, honestly the amount I am eating! The weather so far has been not too good, but on Monday I am venturing into the sea. On the train up there was a bomb scare it was quite frightening with all the police and everything. See you soon, Mandy. Are you having any benefit from the new hearing aid?

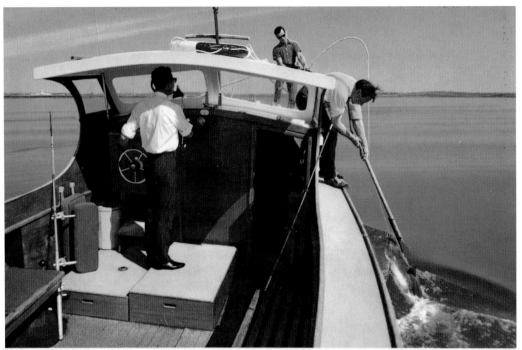

Deep Sea Fishing off the Irish Coast.

Photo : Joan Willis, John Hinde Studios.

July 1960, sent to Northumberland
They are dipping here now in the NE corner. No one I knew and I didn't ask for Wilf. I don't suppose I ever will now! M x

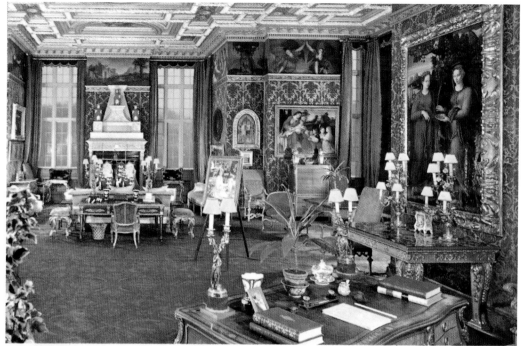

The Drawing Room, Longleat, Warminster, Wilts.

Photo : E. Nägele, John Hinde Studios.

4 Nov 1994, sent to Radio Times / Burberry Competition
1. Gaberdine
2. Birmingham
3. Jeff Banks, Brenda Emmanus, Caryn Franklin

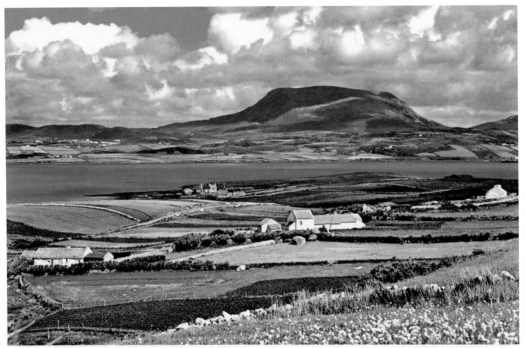

Muckish Mountain, Co. Donegal, Ireland.

Colour Photo by John Hinde, F.R.P.S.

May 1974, sent to Hereford
Louie & John, tunnelled our way out of Towcester and made the Great Escape!! 10 or 11 days of freedom lay ahead of us but alas James was a bit off colour on the way up on Saturday; I went down with dreadful gastric flu on Sunday and one by one they have all gone down. Our chalet looks like a scene from Florence Nightingale; pale faced little boys lying around waiting the next turn to be sick. Angela very groggy. Thursday tomorrow and haven't seen anywhere yet apart from a picnic on Sunday. Alf

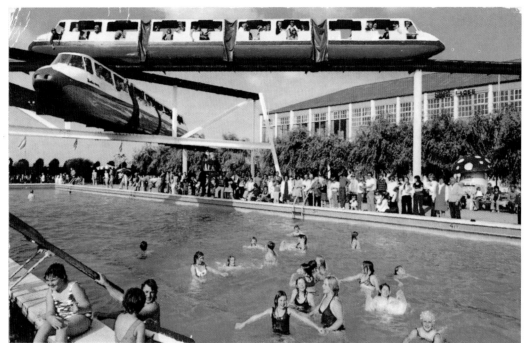

BUTLINLAND MINEHEAD— *Monorail over Outdoor Swimming Pool*

Photo: D. Noble, John Hinde Studios

1 June 1974, sent to Hastings, Sussex
Delighted to hear from you. Shall be out on Friday afternoon. Am usually here in evenings and usually daytimes also but this is not so certain as I have to eat. Tom

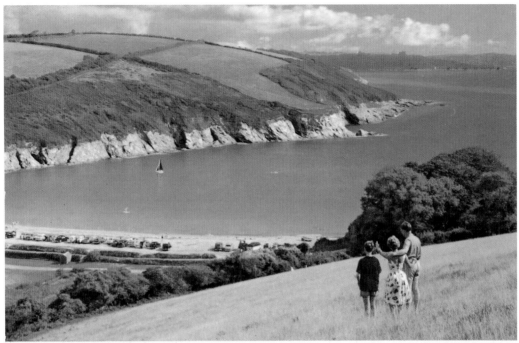

Maen Porth, near Falmouth, Cornwall.

Photo: E. Ludwig, John Hinde Studios.

6 Aug 1976, sent to London
So sorry I haven't been in touch, wondered if I would make this holiday I have to see Mr Durham
(specialist) August 17th. "Things" just have been going from bad to worse - we are enjoying this holiday
altho' at the moment it is pouring and my friend and I are waiting for the return of the 2 children who
are on a trip n a train. We are sitting in a car park.

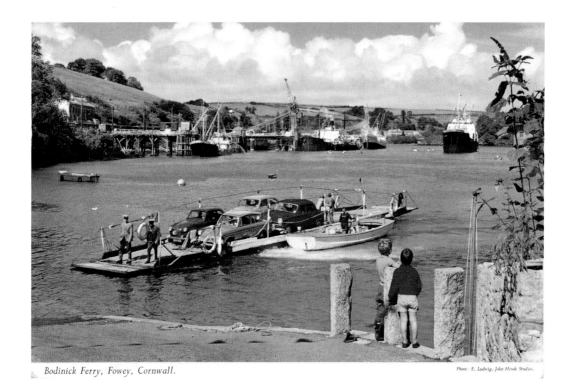

Bodinick Ferry, Fowey, Cornwall.

Photo: E. Ludwig, John Hinde Studios.

1 July 1966, sent to Malvern, Worcestershire
Tried to call you. It was a last minute decision…best wishes Gordon

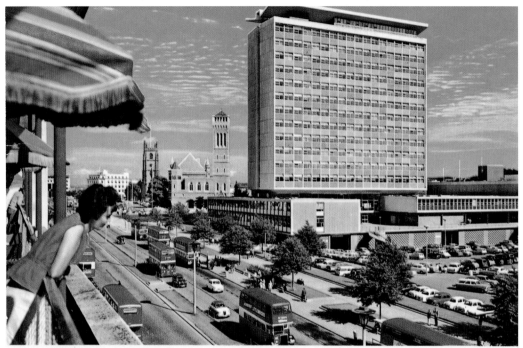

Municipal Offices and Royal Parade, Plymouth, Devon. Photo: E. Ludwig. John Hinde Studios.

22 Aug 1966, sent to Londonderry, Northern Ireland
Rue & Daisy, we came Friday evening I went to Infirmary 9.30. Betty took me. The doctor took it off and I am strapped to knee. The man taking plaster off dug into and gashed my ankle. I fainted and came to on a stretcher. I was sick and dizzy all day. I think the heat upset me. Sick I packed and was ready to go when Ivor came home. I feel much better today and so relieved to be rid of that "ton" weight.. Had a nice drive along coast this morning and a nap this afternoon while the fans listened to the cricket. Hope next time to entertain you more regularly. Love Anne

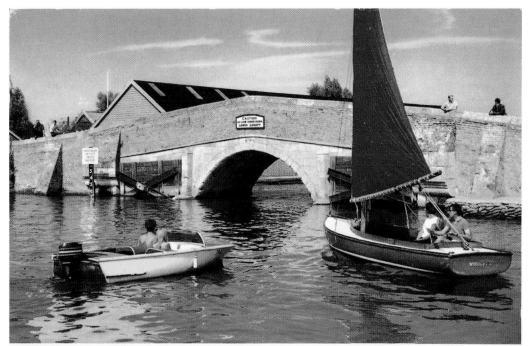

The Bridge, Potter Heigham, Norfolk.

Photo : E. Nägele, John Hinde Studios.

19 Aug 1973, sent to Bride, Isle of Man
G and D, it did us a power of good seeing you - thank you. Basil did appreciate the church flowers - they were lovely. The lettuce is fantastic. How do you keep the slugs off Gail? Wonderful new recipe Dolores. I don't know how you have time to experiment with all you do. Many thanks again. Basil and Charlotte. PS. Basil was sick from the trifle

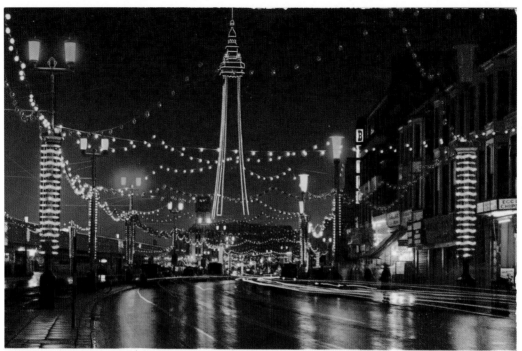

Blackpool Illuminations. The world's most famous Free Show.

Photo: E. Ludwig, John Hinde Studios.

1985, sent to Bath

Dear Donny & Beryl, many thanks for your information on Clematis Wilt. We have cut out all the top growth and have one new shoot from base just showing. Must get a new supply of Benlate and see if that helps. Almost too hot over weekend to do much in garden and today have had to deal with several bits of correspondence. I mowed the lawn this morning and it very nearly killed me. Love Olive & Sid

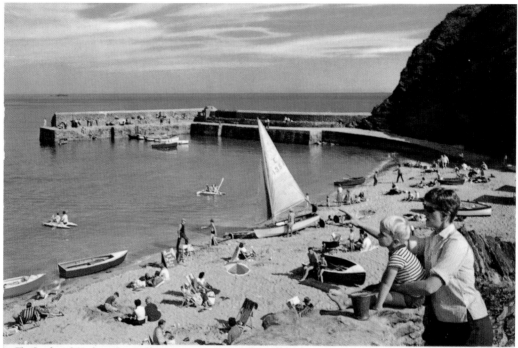

The Beach and Harbour Gorran Haven, near Mevagissey, Cornwall. Photo: E. Ludwig, John Hinde Studios.

Date unknown, sent to Seaton, Devon
Dear Bush and Toh, just thought I'd show you that I had given you a little thought while I was on holiday. The hotel is very comfortable though I am sharing a room with my room mate. Best wishes, Tina

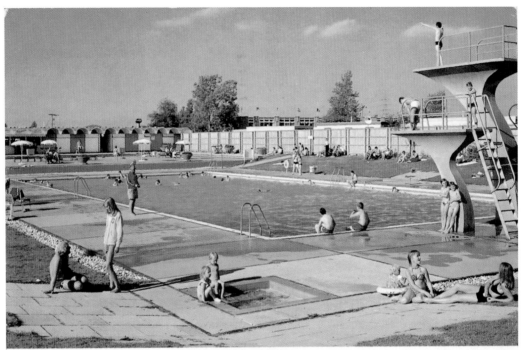

The Tropicana Heated Swimming Pool, Rockley Sands, Poole, Dorset.

24 Sept 1985, sent to Wrexham, Wales
Dear Rachel and the gang, having a fantastic time. Been on plenty of trips. Susan has a crush on a lad called Ricky. P.S. I sent this to you because yours is the only address I know

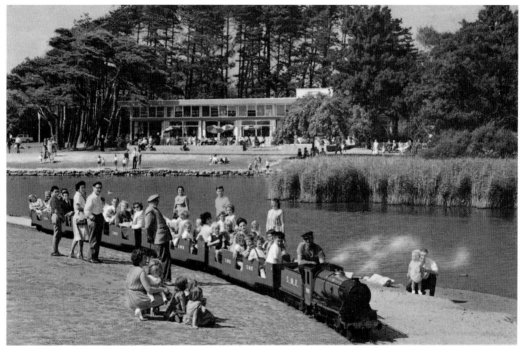

The Miniature Train and Lake, Poole Park, Dorset.

Photo : E. Ludwig. John Hinde Studios.

18 Sept 1978, sent to Yeovil, Somerset
Thank you for the notelet. I am so very sorry you had the fall. It does shake you up to such an extent.
Expect you have been making tomato chutney. The gardener here keeps saying he will bring some
tomatoes but he has a good forgetting! If the coxes are about I should be so grateful if you would get
me some. I shall be here at least another 3 weeks so it leaves it to you. Glad your husband is feeling
better. Have your visitors gone or are they still with you? The weather is so glorious and so hot in the
daytime. Even so it soon goes cool by dark. So lovely here I feel I shall miss it when I come home. Love
to you both, Hilda

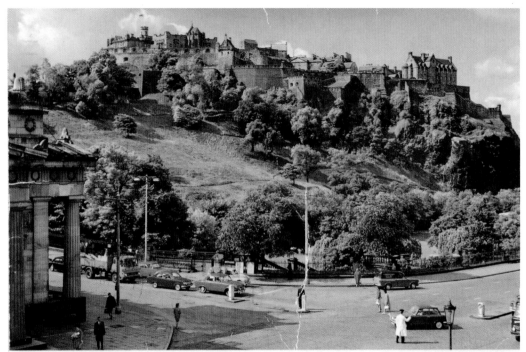

Edinburgh Castle, Edinburgh.

Photo: E. Ludwig. John Hinde Studios.

25 Aug 1975, sent to Hove, Sussex
Hi, yes I actually went here BR rail away day. We actually got up at, wait for it, 6am!!! Had a great day although a coach tour was lousy. They showed us the sewage works, the dogs home, the orthopaedic hospital and a cancer home to name but a few. We are going home now looking across at the Forth bridge. The tattoo is on - we should have gone to that instead of the coach tour. Will ring you some time, love Rosie. Sorry I forgot to post this

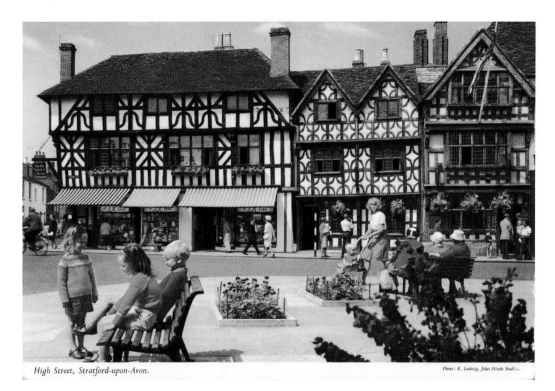

High Street, Stratford-upon-Avon.

Photo: E. Ludwig, John Hinde Studios.

Date unknown, sent to Dudley, Birmingham
Dear Dorothy, have been at Bilston, Warley and are now back at Bilston. My friend at Warley's husband died suddenly - my sister had a very bad fall down a circular staircase at Wolverhampton hospital while visiting a neighbour and my sister's sister in law has died suddenly, so have been flitting to and fro. Yours Doris

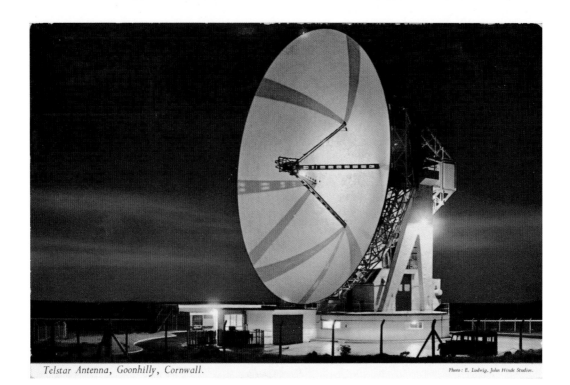

Telstar Antenna, Goonhilly, Cornwall.

Photo: E. Ludwig. John Hinde Studios.

12 July 1966, sent to Sheffield, Yorkshire
Dear Elsie & Bob, we are all having a jolly time weather perfect went to Newquay yesterday afternoon.
Mum and Uncle Joe laying on the lawn I am just going to take them a cup of tea. With lots of love P

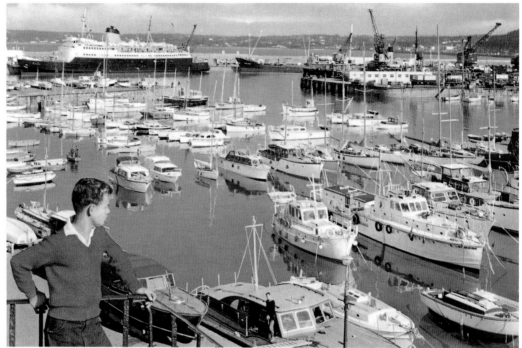

The Harbour, St. Helier, Jersey, C.I.

Photo : E. Ludwig, John Hinde Studios.

1988, sent to St Martins Infant School, Bedfordshire
Tell Jesus you love him

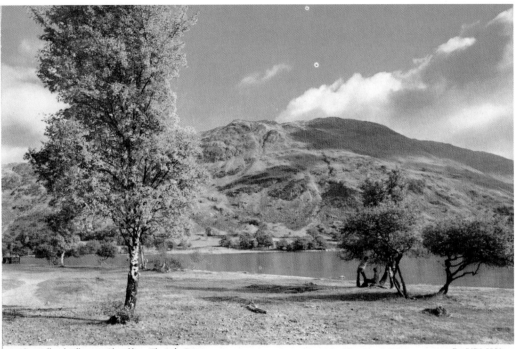

Place Fell and Ullswater, Glenridding, The Lake District.

Photo: E. Nägele, F.R.P.S.

1 Sept 1976, sent to Stoke on Trent, Staffordshire
Dear Joan, how nice of you to ring Wed, it was an awful weekend and to top it all on Thurs the electric
sub station by our gate blew up result of the sun. So had to have the time away. Love Ron & Pip

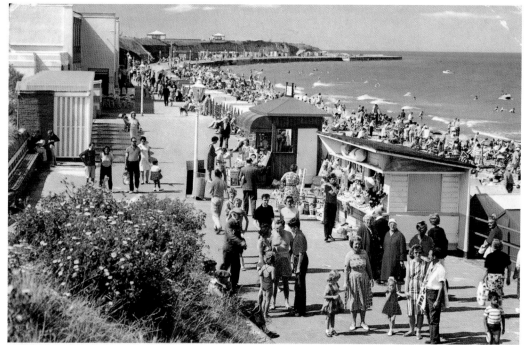

The Promenade, Westbrook, Margate.

Photo : Joan Willis, John Hinde Studios.

28 July 1970, sent to Surrey
Hi I'm having a fab time with absolutely gorgeous weather (whether you spell weather like that or not I don't know!!) We are staying at an Uncles farm and we're having fun chasing cows and stacking hay bales. Oh and there's Steve as well but he's a long story (exceedingly long he puts Nigel to shame) I'll tell you later. See ya, Julie

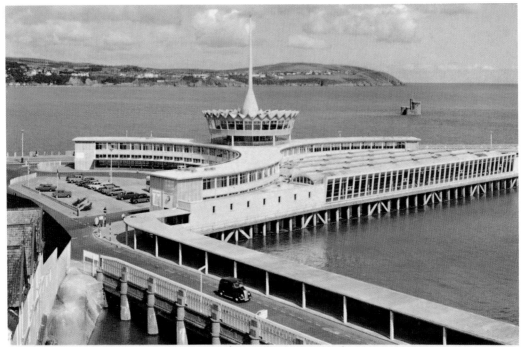

Sea Terminal Showing The Tower of Refuge, Douglas, Isle of Man.

Photo : E. Nägele, John Hinde Studios.

27 Aug 1981, sent to Bradford
Dear Paul, Many thanks for your card. As I'm on holiday in Yeovil and thought I'd send you this card as well. If you're reading this you've probably escaped from Scotland. You can't trust a man that's wearing a dress, that's what I say. If you were very unlucky you might even come across RB. You'll probably get this card the same time as my letter. If you do, a word of warning- don't open it. Its full of nasty words, paper, full stops and things. It also contains several genetically imperfect squashed rabbit droppings. Who put these words in the way? Please send down some of that rain you had in Scotland as I like rain. I bet they have charged you for it. Oh well, hope your feet are forever furry etc. Annonymous.

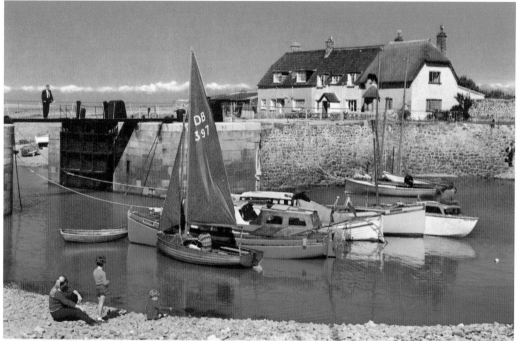

Porlock Wier, Somerset.

Photo: E. Ludwig, John Hinde Studios.

1980, sent to Solihull, West Midlands
Dear Deb, have just arrived on holiday . Weather fair. The journey was appauling through a break down.
Sorry about the bad writing but have broken my fingers through fall. Good luck with the results. Love
Pauline

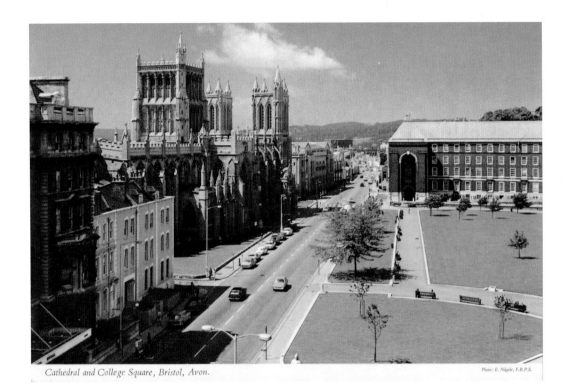

Cathedral and College Square, Bristol, Avon. Photo: E. Nägele, F.R.P.S.

Date unknown, sent to Colwell, Northumberland
Good game of snooker between Davis & Taylor. Had a nasty fall outside Woolworths in Broadmead at
9.00 0'clock this morning knocked myself out. The paper man had thrown his papers down and I got
my feet caught. Did not make me laugh had to go to hospital for check up (see you John)

La Saline and Grande Rocque, Guernsey, C.I.

Photo: E. Nägele, John Hinde Studios.

20 March 1963, sent to Credition, Devon
Dear Milly, I got some material exactly like the piece of wool, so we were very lucky. I think you will like it, it is plain, but that's what you wanted, the shops are lovely and you would have liked to be along today I guess. Ive had to sew and sew as Esthers things are all too small. Hope you are better. Love Granny

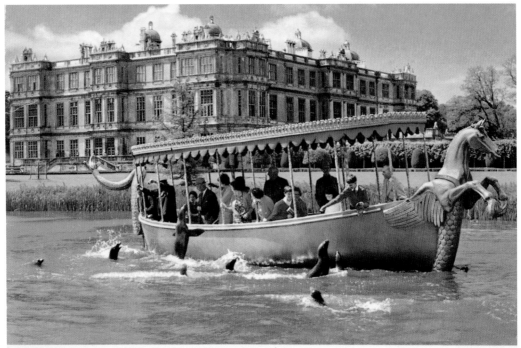

Safari on the Lake, Longleat Park, Warminster, Wilts.

Photo: E. Ludwig, John Hinde Studios.

29th Sept 1975, sent to Welwyn Garden City, Hertfordshire
Just using up old cards. Arr. Ok, saw the burnt out shops today. "City precincts" still mopping up! Off for a walk round Sefton Park. Love to all, Mum & Dad

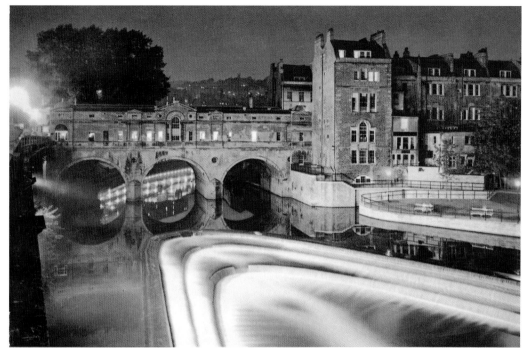

Pulteney Bridge, Bath, Avon.

Photo: E. Nägele, F.R.P.S.

19 June 1986, sent to Weston S Mare, Avon
Hello Dad. Thanks for your letter sorry to hear about you having your choppers out. Hope their will not be to much pain. The Russian trip I was on about is definetly on recieved all my stuff for visa today. In Bath today hardly any Yanks here like other years all frightened of this terrorist business. Been glued to the box watching the football (See You Soon Love Eric)

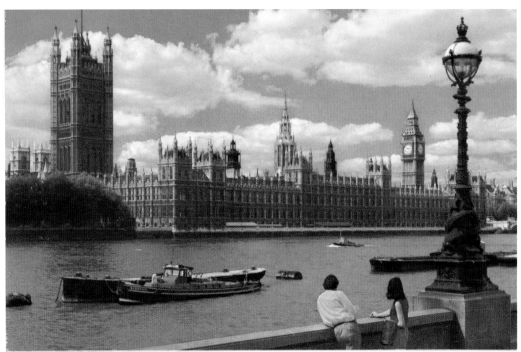

The Houses of Parliament and the River Thames, London.

18 Aug 1968

Dear Caroline, how are you? I hope you are enjoying the holidays. I wonder if you went on the outing in July with the Peruvian congregation. Granny is spoiling me with hot water bottles and twice breakfast in bed! Bobbie, Charlie, Lionel and Dolly have been staying here all the time and Uncle rob and co were here for a few days. It was great fun all together. William is a sweet little boy. Cordelia was very pleased with the Edwardian blouse. We felt very grand at Buckingham Palace, driving in past all the crowds! The tea was delicious and it all looked gay with all the purple cassocks and pretty dresses on the green grass. There are flamingos on the lake, and lovely flowers. Daddy introduced me to lots of Bishops he has made friends with, and we saw Amos, our friend from Uganda. Bobbie is just the same. She is very helpful in the kitchen and plays the piano and the violin very well. Give my love to all the Rileys. Love to you from Mummy xxxxxx

Pembroke, L'Ancresse, Guernsey, C.I.

Photo: H.Gössler, John Hinde Studios.

May 1972, sent to Rickmansworth, Hertfordshire
Hope you are still improving! How far do you walk now? Can't imagine you walking anywhere!!. Love to Ted, love Rene

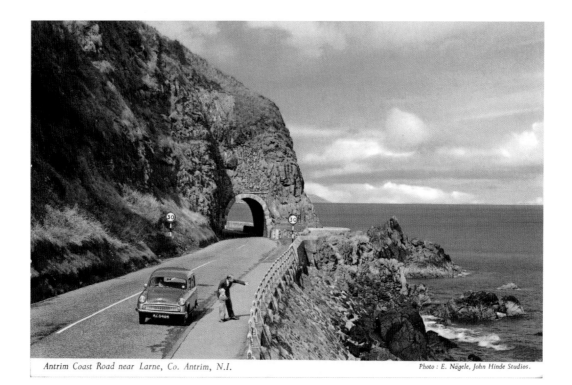

Antrim Coast Road near Larne, Co. Antrim, N.I.

Photo: E. Nägele, John Hinde Studios.

Aug 1969, sent to London
Having a really wonderful time in spite of horrendous journey.. Bat in my bedroom last night and poor bereaved cow moaning under my window all night - also sheep with gyppy tummy. Lot of love Val

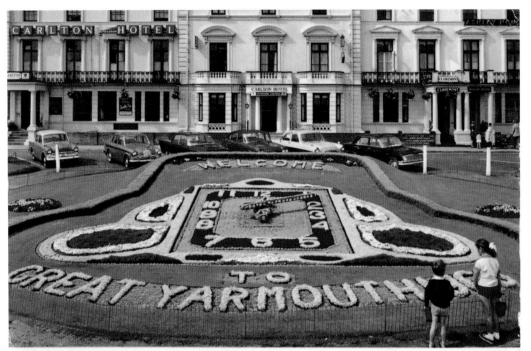

The Floral Clock, Great Yarmouth.

Photo: E. Nägele, F.R.P.S.

30 June 1980, sent to Uttoxeter, Staffordshire
Dear all, have had a very pleasant day wondering around Norwich….a city full of interest. We'll probably do some CHRISTMAS shopping. I see 1981 calendars already in the shops. We also made up my stock of Birthday Cards…it was getting low. I only had 63. Mother is sitting around reading the papers and watching the sun move. The TELLY is hardly ever on I'm pleased to say.
All my love to you all. Sincerely Dick

The City Centre, Bristol, Avon.

Photo: D. Noble, John Hinde Studios.

Date unknown, sent to Basingstoke, Hampshire
Dear Arthur & Andrew, having a wonderful holiday, weather hot and sunny, off now for a quick one. See you Ed & Ted

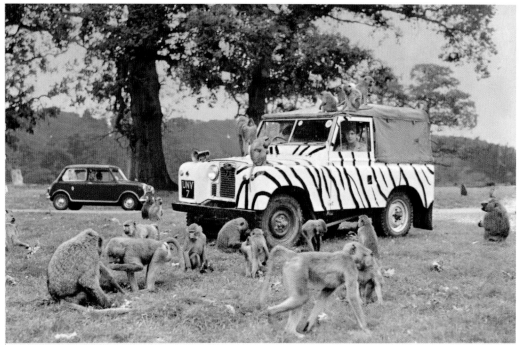

Woburn Wild Animal Kingdom, Woburn Park, Bedfordshire.

1977, sent to Shepton Mallet, Somerset
Sunday. Ett dearest, another addition to your local zoo. Aren't they sweet? I shall forget what the park is like: too cold and unsettled to go there. Are you still watching cricket? I never know whether they are winning or losing: I expect you do. All for now dear. Letter next time. Love and thoughts, Walter

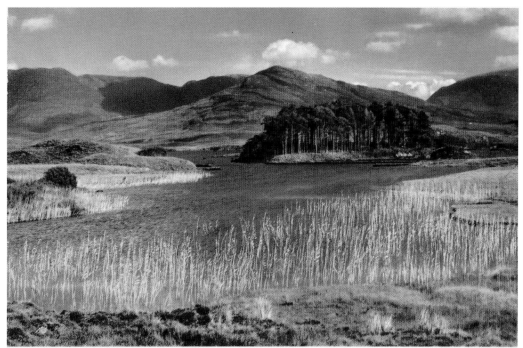

Derryclare Lough near Recess, Connemara, Co. Galway, Ireland. Colour Photo by John Hinde, F.R.P.S.

14 Aug 1975, sent to Taunton, Somerset
Have just packed my case and left it outside the door and am now drinking my tea. Keith had a call from Peter just as I had mine. The weather is better again this morning, lovely dark clouds but lightly spotting. I shall send only one more card. You leave those lawns and hedges alone. I'll soon be back, at work and paying the bills. Take care of yourself, Joan. Glad you've got your radio working!

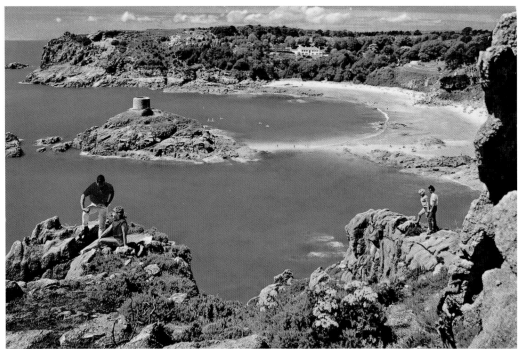

Portelet Bay and the Ile au Guerdain, Jersey, C.I. Photo: E. Ludwig, John Hinde Studios.

12 July 1977, sent to London
My dear girls, the crossing was very rough but our beds were comfortable though we had to return to Weymouth with an ill member of crew, so didn't arrive till 8. The weather bright, windy and showery on Saturday. Sunday dull with showers. Monday cooler with winds off the sea. Today bright periods with scattered showers in spite of which we are enjoying some country drives. Love Mum & Dad

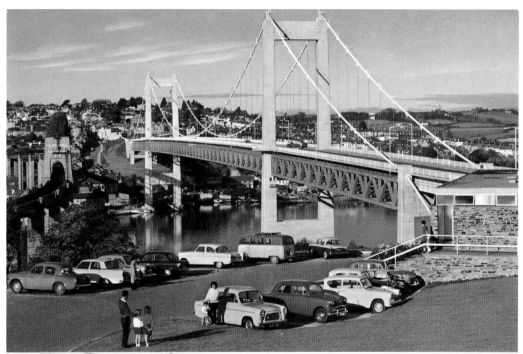

Tamar Bridge, Plymouth, Devon. SALTASH

Photo: E. Ludwig, John Hinde Studios.

9 May 1969, sent to Portree, Skye
Dear Gary, my name is Rebecca Mortimer. I live in Plymouth. My hobbies are Tap dancing, guides, recorder, and violin. I am 10 on my birthday which is on the 23rd February. From Rebecca Mortimer

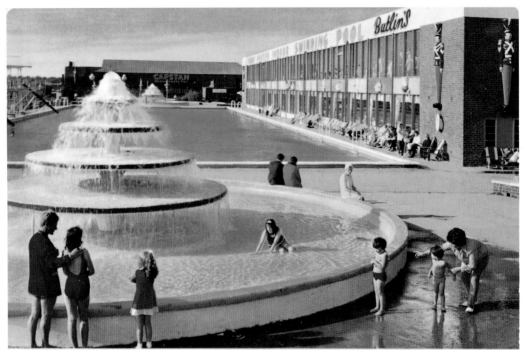

BUTLINLAND FILEY— *The Outdoor Swimming Pool*

Photo : E. Nägele, John Hinde Studios.

1978, sent to Dyfed, Wales

Dear Jo, hope you had a nice journey home on Sunday. It poured with rain all Day here, but it has improved a bit since then. Slightly warmer and sunny. The camp has improved a lot since last year. Will write later yours Violet.

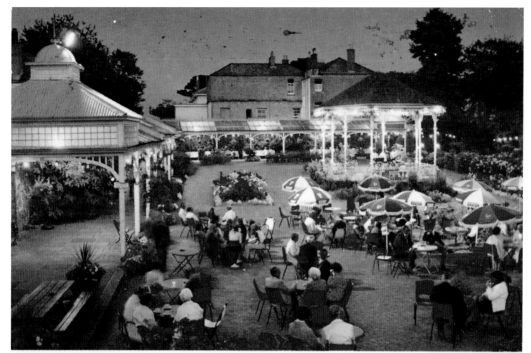

The Beautiful Tyrolean Biergarten, Princess Pavilion, Falmouth.

Photo : E. Nägele, John Hinde Studios.

16 Aug 1978, sent to Worcester
Hello there. We are thoroughly enjoying the break and only wish we could stay longer. We had a 'wee' bit of a setback this morning when a stupid oaf ran into the back of my car (NB I was stationary) and on top of that he appears to have given me a phoney address. We are making our way home tomorrow. Lots of love Reg

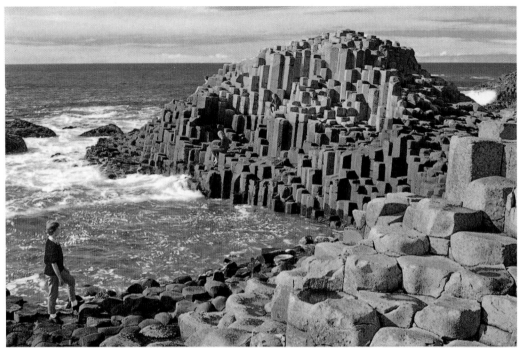

Giant's Causeway, Co. Antrim, N.I.

Photo : E. Nägele, John Hinde Studios.

1972, sent to Sunbury on Thames, Middlesex
I am sorry for the long silence. Greetings Pippa

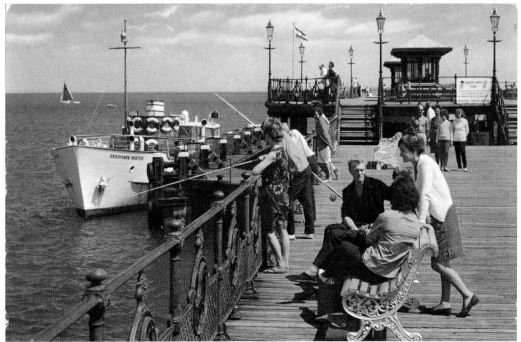

The Pierhead, Swanage, Dorset.

Photo: E. Ludwig, John Hinde Studios.

April 1981, sent to West Grinstead, Sussex
Dear May, many happy returns of the day. Thank you for your company which, as always, I much enjoyed. (Not withstanding your very bad language). Your birthday gift is on its way by post and till it comes do NOT buy or seek to acquire a solitaire board! (Or marbles). See you soon, yours sincerely Sylvie

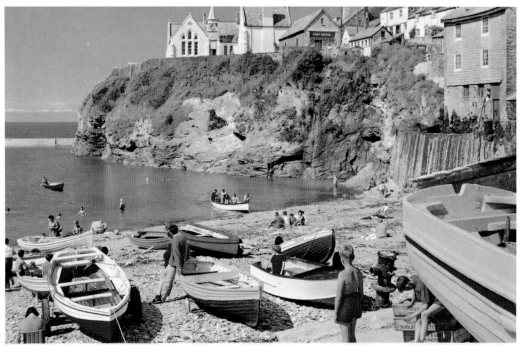

The Beach, Port Isaac, Cornwall.

Colour Photo by John Hinde, F.R.P.S.

Date unknown, sent to Whitby, Yorkshire
I have had a very enjoyable time with good weather, three members of family not well, and one Death, so far I'm fine and hope to arrive home on Thursday. We are having a small party on New Years Day. Kind regards to all

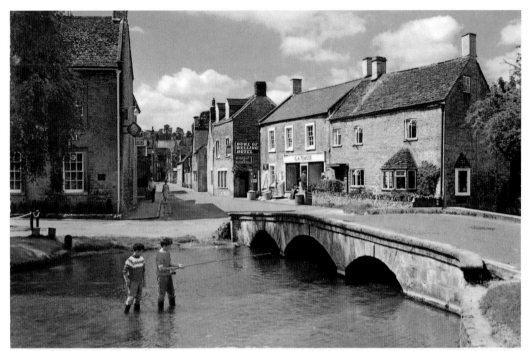

Bourton-on-the-Water and Bridge over River Windrush in the Cotswolds.

July 1975, sent to Shepton Mallet, Somerset
Ett dearest, just a quick post card to catch the 3.30 post. Will write on letter on Sunday. Hope you are well looking at lots of cricket. I watch golf. Who will win? Love Walter

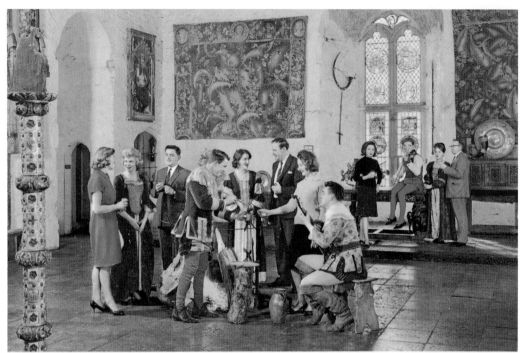

The Great Hall, Bunratty Castle, Co. Clare, Ireland.

Photo: E. Ludwig, John Hinde Studios.

13 Aug 1972, sent to Fareham, Hampshire
My dear Carol, so it looks as though we shall see you at the beginning of term after all. Sorry I couldn't come with Mrs Boyd. (Gas problems). I went to school this morning and our classroom is covered with dust where they are doing the alterations. With love from Mrs McLuckie

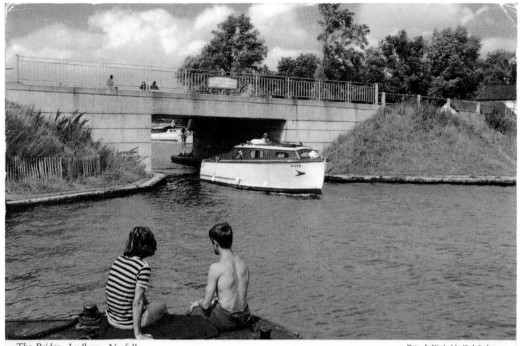

The Bridge, Ludham, Norfolk.

Photo: E. Nägele, John Hinde Studios.

7 Sept 1978, sent to Dartford, Kent
Dear Marie & Digger, having a time. Site very quiet, only tourers here. Only two couples on site with two normal children. We've been frozen, misted, roasted and washed off the road. Lots of shops and Timmy's made friends with the sheep dog. He is playing football with it now. Lots of love from the zoo.

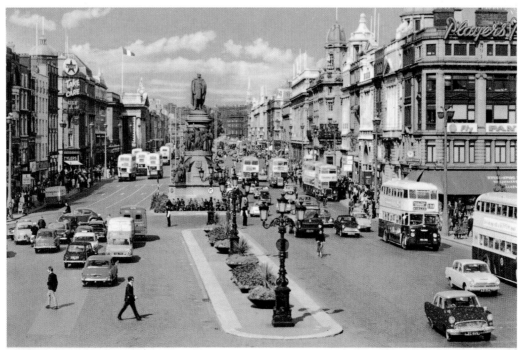

O'Connell Street, Dublin, Ireland.

Photo: J. Willis, John Hinde Studios.

27 July 1970, sent to Dagenham, Essex
Dear Lou and Howie, spending some time in Wales but I'm driving and we took a wrong turn somewhere!! Actually have come to Ireland for the day to see what all the fuss is about. But as we set off at 3 am and its cloudy - I'm not impressed. Wait a minute - the sun has just come out! Love Nan

The Globe, Swanage, Dorset.

Photo : E. Nägele, John Hinde Studios.

15 Aug 1973, sent to St Leonards on Sea, Sussex
Dear Jack and Percy, I am enjoying my holiday at Swanage. We have found an octopus a sea spider and two large sea urchins when we went rock pooling. Lots of love Orianna xxxx We saw a life size guide dog box

St. Nicholas Park, Warwick.

Photo: E. Nägele, F.R.P.S.

26 July 1978, sent to Liverpool
Near Stratford, lunch stop, 2.40. Wasn't I glad to have a lovely one with me. Terrible thunder storm at Nottingham, actually. Love Sis

Cottages at Dunster, Somerset.

Color Photo by John Hinde, F.R.P.S.

24 May 1982, sent to Monmouth, Gloucestershire
On route to Woolacombe. Stayed here last night. Brian is queuing for a stamp. Love JB SC

The King's School Shop, Canterbury, Kent.

Photo : E. Nägele, John Hinde Studios.

18 Jan 1979, sent to Loxley Hall School, Staffordshire
Dear Elvis, hope you are alright, your dad wants to know if you have made up your mind to be a good lad if he fetches you home, or if you are still going to cheek him bad when he tells you anything. You have also got to learn to be more tidy, you have left your room in a state again. Dorothy xxx

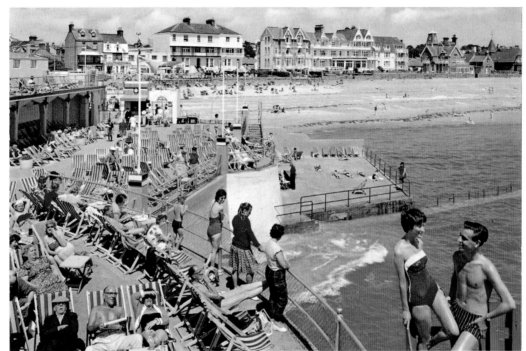

The Swimming Pool, Havre-des-Pas, Jersey, C.I.

Photo: E. Ludwig, John Hinde Studios.

29 Jan 1971, sent to Cockermouth, Cumberland
This is a very nice hospital and everybody is kind but I'll be glad to see the back of it. Love mother

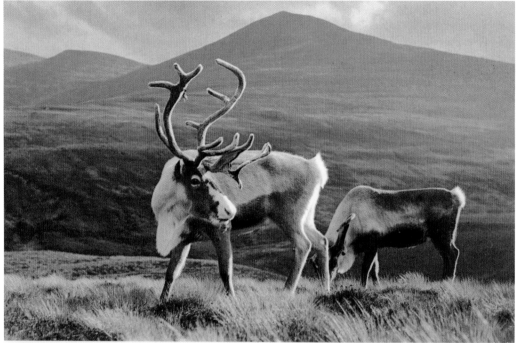

Reindeer in the Scottish Highlands.

12 June 1986, sent to Catel, Guernsey
Dear Mum, Contacted Jerry and he and Pam are divorced, but still great friends, and very fond of each other. I asked why divorce. He said the pressures of being together made it look as though they wouldn't have remained fond of each other, so they split. Tell Joan that one of the kids from school succeeded in breaking the parker pen she gave me when I lent it to him, but his father sent me £4 to buy another. This is the replacement. Dave.

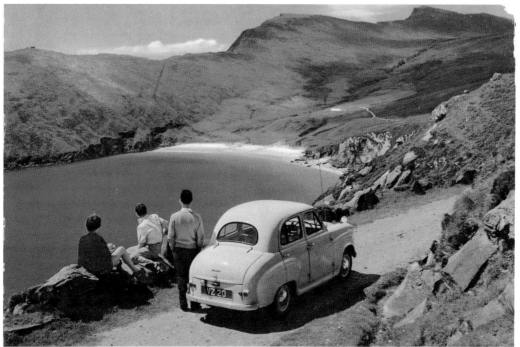

On the road to Keem Strand, Achill Island, Co. Mayo, Ireland.

Colour Photo by John Hinde, F.R.P.S.

Sept 1974, sent to Hungerford, Berkshire
Dear mum and dad, we are going to see the fireworks this evening. I hope this will be the highlight of the week to overcome the mistakes. I don't think my idea of touring is Linda's. The only pleasant thing is to make her happy. Love Richard. Keep the card please

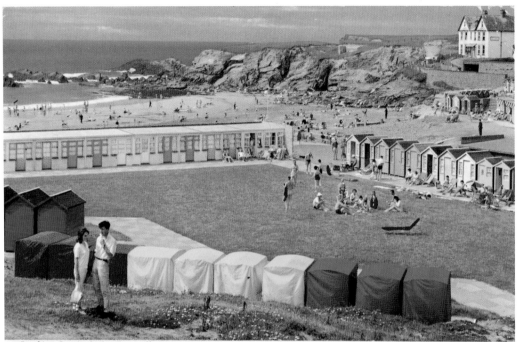

Crooklets Beach, Bude, Cornwall. Photo: E. Ludwig, John Hinde Studios.

28 Jan 1966, sent to Wolverhampton
Dear J, thank you for letter and Cathy. Hope you are all well. Sent it cold and nasty. Gone foggy again here tonight. Do you know if mother still gets on the floor for scrubbing? I've seen some proper kneeling things or would she rather have a brush on a handle I'm thinking of her birthday. Must go now. Love H & A

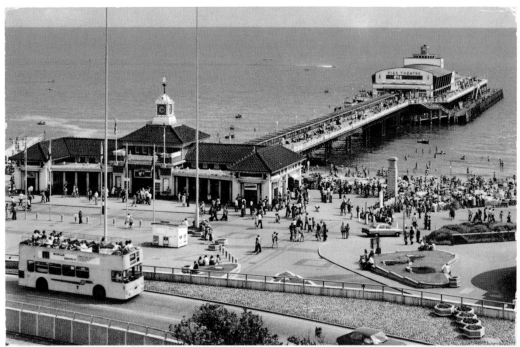

The Pier Approach, Bournemouth, Dorset.

Photo: D. Noble, John Hinde Studios.

1973, sent to Fishguard, Wales
Dear friends, we had a good journey here and the weather is fine and nice home good food. We went to see the show last night and the B & W minstrels Thurs night. Love E & G Blythe

Trafalgar Square Fountains, London.

Photo: E. Nägele. John Hinde Studios.

24 Nov 1974, sent to Blandford, Dorset
I went to see Natural history museum. I saw the bonses of Dinosaurs. I went to the British museum and saw Egyptian mummies. Love from C.B.Dukes

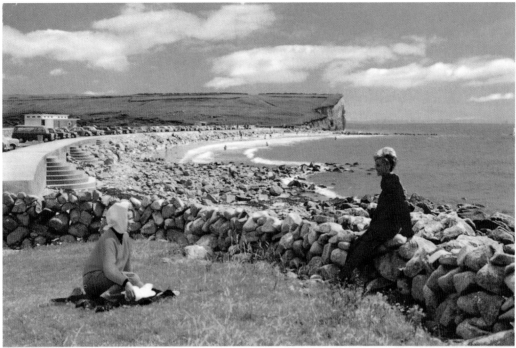

The Silver Strand, Barna, Co. Galway, Ireland.

Photo: Joan Willis, John Hinde Studios.

1969, sent to Staffordshire
Dear Enid, l remembered when we were about 12 years old at the Old Beer garden. That was a little bit of heaven. Many moons have waxed and waned since then. Bert

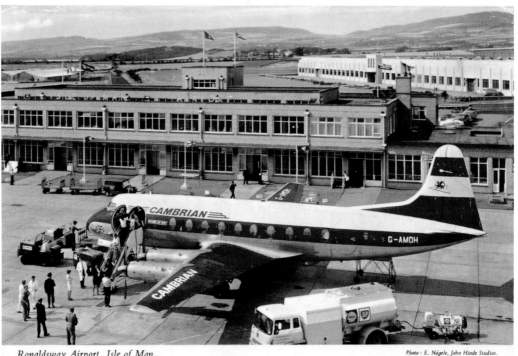

Ronaldsway Airport, Isle of Man.

Photo: E. Nägele, John Hinde Studios.

Date unknown, sent to Leeds, Yorkshire
Dear Andrew, by the time you get this your Nanny and Grandad will be with you. I cant help wishing I was with them. Can you remember the last time we met? I cant. Its a long time. I know my Patsies fur makes you breathe badly. Hope you have a Happy Birthday, love Auntie Tissy and Patsie. I thought you'd prefer this card instead of the cats, they make you sneeze

Kilchurn Castle and Loch Awe, Argyll, Scotland.

Photo: E. Ludwig, John Hinde Studios.

15 July 1990, sent to Bristol
Dear Susan, here is a picture of my new castle and all the land I own since becoming a very famous indeed record producer. I trust I shall be treated with the appropriate respect upon my return. Please kiss my girls for me when/if you see them. Fond regards JP

Rannoch Moor, Perthshire

Photo : E. Ludwig, John Hinde Studios.

15 July 1970, sent to Inverness
We are touring again this year in Scotland. It was to have been Ireland but we decided to give it a miss in case of trouble. The weather has been mixed but we are enjoying the change. Hannah.

Hall's Croft, Stratford-upon-Avon.

Photo: E. Ludwig, John Hinde Studios.

1963, sent to Gloucester
Dear Mum & Dad, I am having a nice time. The family are good to me and I share a room with 40 rabbits. They also have 2 dogs (shooting) 1 pheasant and some doves. The weather is nice apart from a couple of showers. Catherines Grand-parents live next door! They have a door through. Anyway I must go now. I miss you all. Say hello to bugs for me. Love Sian xxxx P.S. I'm writing a diary so you can read it when I get home.

Ballybunion Town, Co. Kerry, Ireland.

Colour Photo by John Hinde, F.R.P.S.

12 Aug 1974, sent Newton Abbot, Devon
Dear Mum Dad. Just to let you know I OK. Still waiting for immergration to let me know if I can work their on the illand. Should kown Friday if can go will come and see you for a week or so. Wait for work permit if I don't get the job I will go back to Melbourne. Met quite a few friends in London. Love Eddy

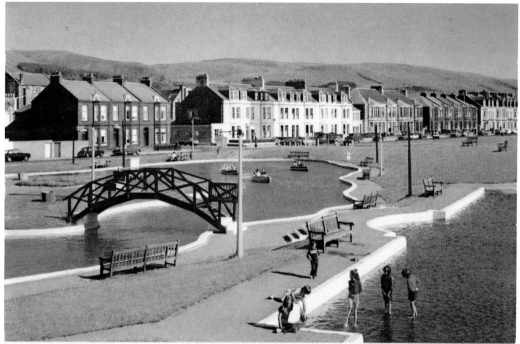

The Boating Lake, Girvan.

Photo: E. Nagele, F.R.P.S.

1978, sent to Northern Ireland
Just over for the day. Will be home on Thursday. G

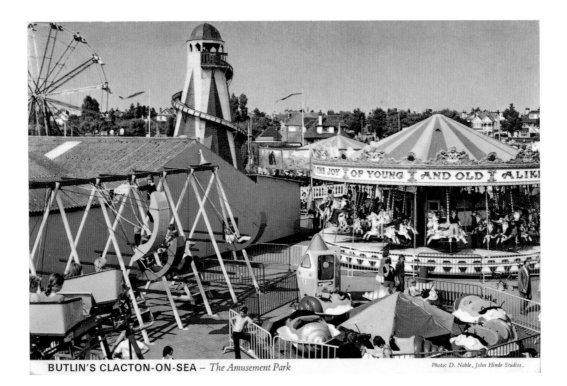

BUTLIN'S CLACTON-ON-SEA – *The Amusement Park*

Photo: D. Noble, John Hinde Studios.

1979, sent to Bracknell, Berkshire
To Fran, we are having a lovely time we are near the sea there are too swimming pools, one inside and one outside. The weather is fine but cloudy. I have been to the Amusment park which everything is free. I have been Gambling at the casino and won quite alot. best wishes Tony

Tilly Whim Caves, Swanage, Dorset.

Photo : E. Nägele, John Hinde Studios.

9 June 1960, sent to Betchworth, Surrey
Have just written labels for cream so hope you will get some for the week-end. In case that is a long time on the way and is spoilt I will bring some with me. I have sent some to Auntie Nan at the same time, heres hoping. It is much cooler with rough seas. There will be no cobwebs on me. Am feeling fit and off for a tramp. Love Edie

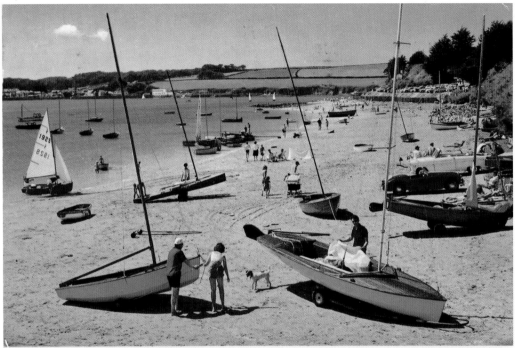

Rock on River Camel, Near Wadebridge, Cornwall.

Colour Photo by John Hinde, F.R.P.S.

6 Aug 1974, sent to Langport, Somerset
Dear Debora, I am writing this as I walk along because I forgot at first so that's why its not very readable.
I have had a great time. We have been evangelising on the beaches and I've helping some of the time
with the children group. In the evening we run a free coffee bar and talk to all the freaks that come in. 9
of us got baptized in the sea at Looe yesterday with all our clothes on I got both my a levels see you soon
god bless love Nigel.

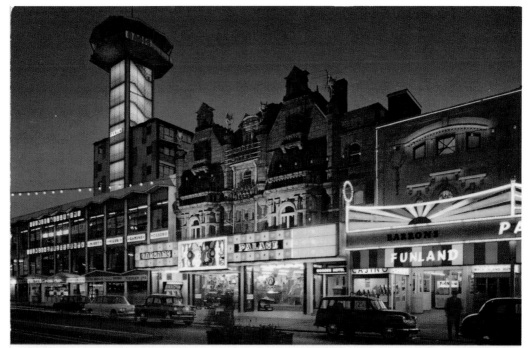

The Oasis Tower by night, Great Yarmouth.

Photo: E. Nägele, F.R.P.S.

1974, sent to Surrey
Dear Nanny & Aunty Elsie, we arrived at 1.30 and everywhere was shut. We had fish and chips for dins on the grass. The place looks pretty poor outside but inside is very quaint. Everyone thinks we mad. We're terrible going out, we really are. We got up and went for walk on the beach this morning at 7. Whilst we were unpacking, the sun was pouring in, today, there is no sun and we want to go onto the beach. The chain in one loo won't flush, the leg on Melanie's bed fell off, the windows are cracked, the fridge wouldn't go after dad pressed a red button (but is now going), dad threw a bone and it made a mess on the ceiling. Bye. Love Marian

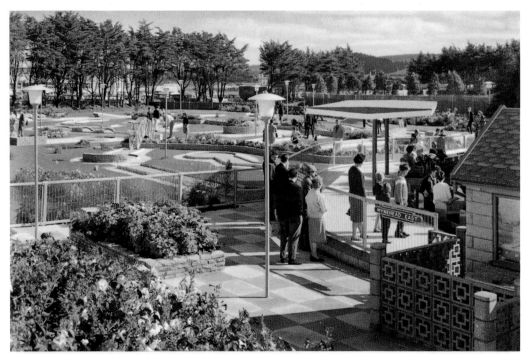

Miniature Railway and Crazy Golf Course, Minehead.

Photo: E. Ludwig, John Hinde Studios.

23 Aug 1982, sent to Marazion, Cornwall
Weather lovely today, but has been showery all week. Hope you are well, everyone ok here, except John's back is bad, he is off work. Had a go at bingo, houses of £120 and £325 but no luck, hope to go again sometime (with better luck, I hope). Had to get new frames for my glasses, one expense I didn't need . £26.40. Still the change is doing us good. Love from Bis & Gordon.

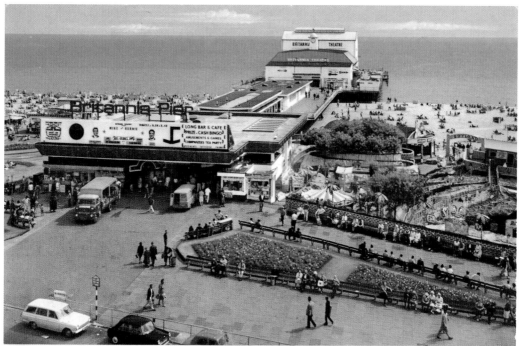

Britannia Pier, Great Yarmouth, Norfolk.

Photo : E. Nägele, John Hinde Studios.

10 June 1971, sent to Leatherhead, Surrey
Dear Hilda (Legs and back just as odd and a little troublesome) Had a lovely night last night, We had an organist, my god could he play, all the party got together for a real good sing song. Up to bed at 1A.M. Sybils friend has turned again so shes happy. We have very good company. Hope alls well with you, Love Nip

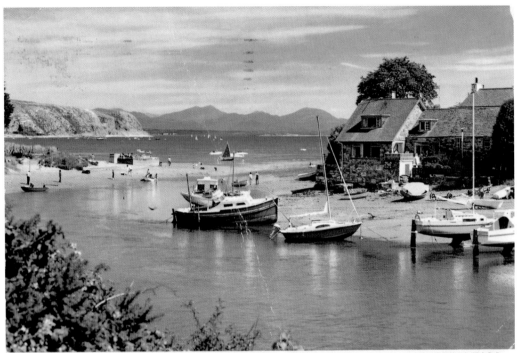

Abersoch Bay, Lleyn Peninsula.

Photo: D. Noble, John Hinde Studios.

Date unknown, sent to Loughborough, Leicestershire
Dear Geffrey, sorry I left the o out of your name, but I am sure you will forgive me. Can you count all the boats? Love Auntie Irene.

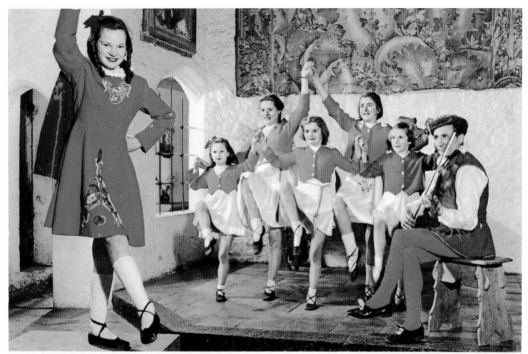

Traditional Irish Dancers, Ennis, Co. Clare, Ireland.

Photo: E. Ludwig, John Hinde Studios.

29 May 1980, sent to London
Dear David, hope you have been enjoying the half term holiday. Ireland has been beautiful. Looking up lots of local history and draught guiness which is out of this world. But I must admit that being with my parents all the time has been somewhat tiring. All the old tensions of family life have re-emerged. We hope to be back in England tomorrow night but the strike could interfere. No doubt I'll see you before this card reaches you. Regards Ian

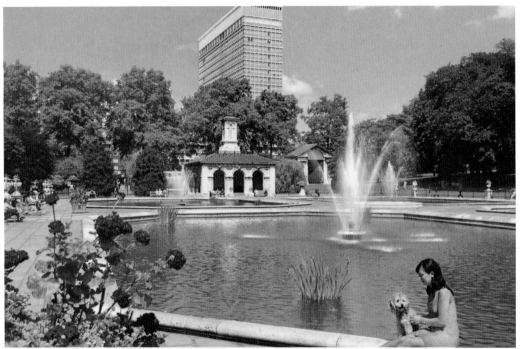

Royal Lancaster Hotel and Kensington Gardens, London.

Photo : E. Nägele, John Hinde Studios.

21 Sept 1973, sent to Aberdeen, Scotland
Finding our way around, nae sae bad, have got very muddled at times. Have done one or two of the tours you sugested and enjoyed them. Weather at first was good but it has broken down and yesterday as you will have heard in the news we had a proper deluge which has carried on right to this forenoon but it is looking clearer now. Allan lost his Pac a Mac so we are waiting till it clears or we get out to get another one Love Alise & Allan

Crummock Water, Cumbria.

Photo: E. Nägele, F.R.P.S.

Date unknown, sent to Ealing, London
I have been blessed by the weather this week, cold and sunny. Mummy is now having a coffee with cream, I can only have so much promenading in the fresh air at once, and I want to go to the Post Office. So much to do!! So little time!! SUSAN

Motor Racing at St. Ouen's Bay, Jersey, C.I.

Photo : E. Ludwig, John Hinde Studios.

10 June 1969, sent to Bristol
Dear dad & mum, glad to hear you've finished the kitchen, But I shan't be home just yet to see it, Alan will be up to see you (I hope) and tell you the stories, cause I have to work, we don't want to lose this job. Hope the lawns coming on well. Enjoy the quiet while i'm away, cause it won't last, how are the fish? Tell Hazel I haven't forgotten her every body's waiting for cards. Bye For Now Love Colin x
PS I'll manage a letter some time

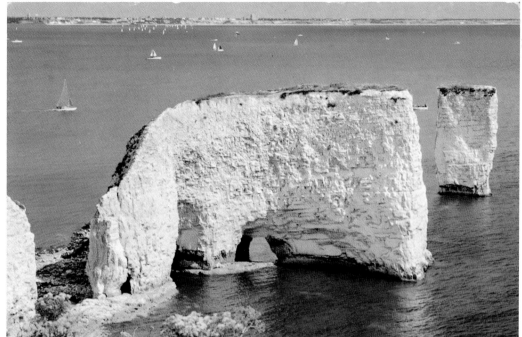

Old Harry Rocks, Swanage, Dorset.

Photo : E. Nägele, John Hinde Studios.

10 June 1966, sent to London
Heavenly!! Betty

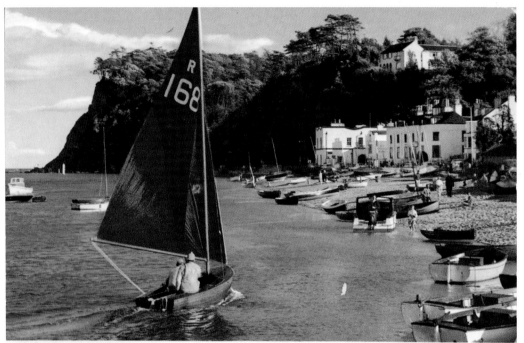

Sailing at Shaldon, Devon.

Photo: E. Nägele, John Hinde Studios.

25 July 1971, sent to Lymington, Hampshire
Dear Lesley, having a good time and was sick Friday night but I have a queer tongue it is partly white but apart from that been alright. Oh Tracy has been getting on my nerves as you can see by the mistakes. See you soon. Love Tina

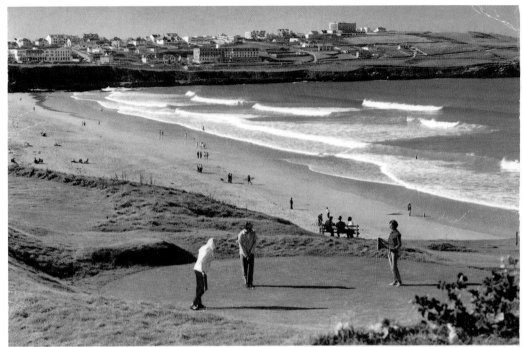

Fistral Bay, Pentire Point, Newquay, Cornwall.

Photo: E. Ludwig, John Hinde Studios.

1986, sent to Manchester
Pleasant enough spot with attractive scenery and sandy beaches, those without car parks are surprisingly empty. But precipitous cliffs and dangerous current only surfing is possible in the sea but the tide leaves a number of pools adequate for the children to paddle and swim in. Quiet site, with a limited number of vans round the perimeter of a field so lots of space to play. Graded as high class by Ronald a) because of the surrounding accents b) the lack of graffiti in the cloakrooms R & R

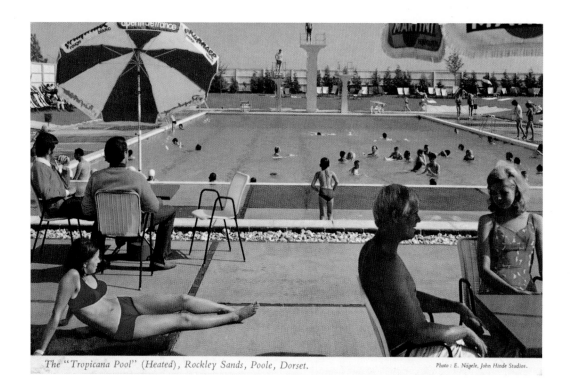

The "Tropicana Pool" (Heated), Rockley Sands, Poole, Dorset.

Photo : E. Nägele, John Hinde Studios.

7 Aug 1967, sent to Brighton, Sussex
Just to make you feel jealous, we have just listened to Reg. Dixon for 1 hour. Smashing programme. Len

Traditional Jaunting Car Touring Lower Lake, Killarney, Ireland. Colour Photo by John Hinde, F.R.P.S.

Feb 1999, sent to Swanage, Dorset
Many thanks for your photographs. It must have been a work of art (the cake). We certainly enjoyed eating our share. I gave Janet the flowers to show the lady who advised in our aspect of decoration, couldn't have bared to eat them anyway! We were mother sitting when you were returning from cornwall so wouldn't have been here. Love D&D.

Wendron Forge, Helston, Cornwall.

Photo: E. Nägele, F.R.P.S.

9 May 1975, sent to Gwynedd, Wales
Dear Auntie, we are staying at a cottage for 2 weeks and helping Lesley with her fossils. The cottage is super - at the end of a lane but with electric light and bathroom - there are heaps of birds and rabbit and swallows in the outhouse. Lots of love Joan

The Beach, Combe Martin, Devon.

Colour Photo by John Hinde, F.R.P.S.

30 July 1979, sent to London
I think perhaps cousins should be drowned at birth! My head is all dented on account of the brick wall!!
Lots of love Elaine.

Sandbanks to Studland Car Ferry, Dorset.

Photo : E. Nägele, John Hinde Studios.

1973, Sent to Lymington, Hampshire

Dear Pat & Paul, just a greeting for easter and a warmer spring. We are now in winter weather with snow showers. I saw announcement of Helen Cook's engagement in Courier. Glad to know you are to be grand parents, very young ones in mind. A bob a jobber Cub cut my grass close to chest so I can now get to work on it. Expect your garden is gay as the flowers (here) have been blooming all winter. Lots of love Kath

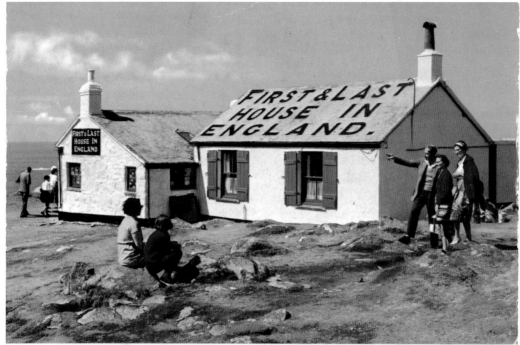

"The First and Last House in England", Land's End, Cornwall.

Photo: E. Ludwig, John Hinde Studios.

23 August 1974, sent to Norwich. Norfolk
Dear All, Yippee. I passed my English G.C.E. Letter to follow. Caron

Who cares?

Imelda Redmond, Chief Executive, Carers UK

This book allows us a fascinating glimpse into the ups and downs of other people's families and relationships. Caring for those we love through good times and bad is just a part of everyday life. But for some people, caring comes with a heavy price.

There are six million people in the UK who provide unpaid care by looking after an ill, frail or disabled family member, friend or partner. Carers give so much to society yet as a consequence of caring, they experience ill health, poverty and discrimination. Carers UK is an organisation of carers fighting to end this injustice. We will not stop until people recognise the true value of carers' contribution to society and carers get the practical, financial and emotional support they need. Buying this book will help Carers UK achieve a better deal for carers.

CARERS UK
the voice of carers
www.carersuk.org
registered charity number: 246329